# HOW TO
# TAKE PHOTOS
# THAT MOVE
# HOUSES

DISCLAIMER

The information provided in this book is for educational purposes only. The author and publisher make no warranty, expressed or implied, and assume no responsibility for the accuracy, completeness, of any information, product, or process disclosed, and do not represent that its use would not infringe on privately owned rights. The author and publisher assume no liability for any loss or damage caused or alleged to be caused by the information provided herein. All company names, product names, service marks, and trademarks referred to in this book are the property of their respective owners, and unless otherwise noted, Ed Wolkis and Ed Wolkis Photography are not not affiliated with any of the trademark or service mark holders or vendors referenced herein. Use of a trademark or service mark, or any other term in this book should not be regarded as affecting the validity of the mark.

PUBLISHER

Ed Wolkis Photography

CONTACT

Ed Wolkis

404 351-6115

www.photosthatmovehouses.com

info@photosthatmovehouses.com

ISBN 978-0-615-26054-9

EDITOR

Jeff Barry | SoroDesign

BOOK COVER

Cecilia Sorochin | SoroDesign

PHOTOGRAPHY

All photos by Ed Wolkis unless otherwise indicated.

COVER PHOTOGRAPH LOCATION

River Dwelling cabin rental, Blue Ridge Georgia (404) 309-7248

AUTHOR'S PHOTOGRAPH

Eric Bern Studio, Atlanta

BOOK DESIGN

Cecilia Sorochin | SoroDesign

TYPESET

ITC Galliard by Matthew Carter & Univers by Adrian Frutiger

ILLUSTRATION

'Professor' by Amy Wolkis

# HOW TO
# TAKE PHOTOS THAT MOVE HOUSES

An Easy-Reading Guide for Real Estate Agents, Brokers, Architects, Designers, and anyone who needs to show a property in its best light

## ED WOLKIS

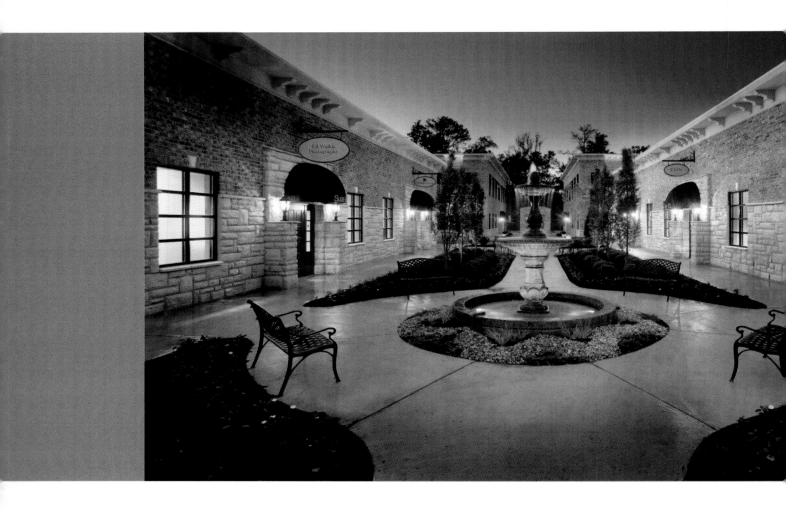

# My Quest...

Two years ago I set out on my year-long quest to find a house. Admittedly, I can be a little picky...I've been known to devote most of a forty-hour work week to finding the perfect birthday card. While scrolling through hundreds of Multiple Listing Service (MLS) properties I was frustrated by what I was finding in my price range. But soon I came to the realization that there were potentially many houses that I might have been thrilled to find. Where were they? They were hiding behind poorly created photographs and sometimes within listings that didn't even have a photo!

Were houses selling like hotcakes with no effort? Or, were sellers not moving properties as effectively as they could? I realized that a little photographic knowledge could be a major benefit to successfully selling real estate. Hence this book.

# Table of **Contents**

Dedicated to my mom, **Bernice.**

# Acknowledgments

First I want to thank my father Phil, his wife Phyllis, and my brother Steve, for their never ending enthusiasm and optimism for new projects, and my daughters Amy and Melissa for giving me a reason to write this book.

Thanks to Larry Thomas, for taking me under his wing almost thirty years ago, generously sharing his photographic knowledge and expertise, and helping me to make the transition from a young naive editorial photographer to a young naive commercial photographer.

Thanks to Jackie Goldstein, who (also, about thirty years ago) would every few months say, "You know, you really should come show us your portfolio," until I finally did, resulting in WSB-TV, CNN, TBS, and the Atlanta television industry becoming the core of my commercial photography business for many years. And thanks to Jackie for her creative input.

Thank you to Jeff Weinberg for helping organize my initial random writings into something resembling a book.

To those who have given me hours of their time and talent: Rhonda Jeffries for her companionship, support, and for being there. Steven Weiniger for blazing the publishing trail, and for the advice. Thanks to Eric Bern, Bobby Horowitz, Steve Neher, Rick Weinberg, Joel Kestenbaum, Rachel Friday, Donna Pearson, Mike Hessing, Ben Curran, Rick Dallas, Chris Scohier, Suzanne David, Darren Keenan, Glenn Gardiner, Ish Reyes, Bruce and Denise Arnold, Carolyn E. Wright and Dave Gorman.

With appreciation to my wonderful clients and everyone whose locations appear in the book: the folks at Founder's Kitchen and Bath, Heather and Dan Kaufman, Kathleen Kenworthy with Peacock Interiors, the Stephenson family, Ray and Gwenn Stanley, Bruce Salzberg, Nan and Rawson Haverty Jr., Dr. Richard Sturm, Randy and Tammy Dugal, Medical Expeditions International, Flying Doctors of America, Highlands Companies, Marc Colando, Atlantic Realty, The Epsten Group, Millenia Design and Build, Integrity Development Group, Sterling Trust, Georgia Tech, Colliers Spectrum Cauble, and Uline Corp.

Thanks to Jeff Barry and Ceci Sorochin with SoroDesign for working their creative and editorial magic.

To all my friends and relatives who took the time to read through my book in progress and give me comments, feedback, and suggestions, my thanks to you all.

And finally, a salute to all of my fellow photographers, Photoshop enthusiasts, and those who enthusiastically share their photographic and digital knowhow for the benefit of everyone. And to Thomas and John Knoll, and the folks at Adobe for creating an incredible program that literally revolutionized our industry.

# Introduction

## Your Prospects "May Not Know Much About Photography, But They Know What They Like."

People respond to great images, even if they don't know why. People, smarter than you and I, spend "beaucoup bucks" on advertising with great graphics. Why? Because it sells.

They say a picture is worth a thousand words. In the real estate, architecture and design business, communicating what a property looks like is essential, and usually impossible to accomplish using words alone. A good picture can be worth thousands of dollars.

This book is for anyone who needs to take photos of buildings: houses, office buildings, stores, interiors, and exteriors. This book is for anyone who needs to make an environment look good, whether you're a real estate agent selling houses, or an architect or interior designer wanting to take photos that showcase the talent and effort you've put into designing a living space. This book is for anyone whose job includes communicating what a property looks and feels like.

If you're an agent or a broker, you want to sell or lease property, you want to be successful at it. You don't want to sit and stare at your property with an MLS number from the twentieth century. If you're willing to do a little reading, and some playing with a camera, I can help.

This book is not meant to replace the services of a professional photographer. The pros have spent years honing their craft and get paid the big bucks because they're good at what they do. But there are times when hiring a pro, for whatever reason, may not be an option.

While I can't immediately give you years of photography experience or bless you with unusual talent, I can help you to take photos that

　　▮▮ *1.* *show a property in its "best light," literally and figuratively,*

　　▮▮ *2.* *bring out the best features of the property,*

　　▮▮ *3.* *look great in magazines, brochures, flyers, and on the Internet,*

　　▮▮ *4.* *are better technically, and*

　　▮▮ *5.* *are done without having to mortgage your home to invest in a truck load*
　　　　*of expensive equipment.*

You will learn what those confusing camera numbers are all about, and how to use them to put you in control of the camera, rather than crossing your fingers and hoping for the best.

You will learn what kind of light works best during what part of the day to make a property look good.

You will learn how to compose a photo…what goes where and why.

You will learn some great tips and techniques, and gain a general understanding of photography that will help you take great photos of everything from your kid's Little League game, to the left-over toast crust in the shape of Elvis' sideburns to sell on eBay.

This book is organized broadly into five sections: The first deals with identifying what makes a good photo. The second deals with photography equipment–lights, cameras, etc. The third section deals with composition–what to put in and what to leave out, and when to add things like a flash or other lighting. The fourth section deals with advanced techniques of lighting, color theory, and using your computer to enhance your photos with Photoshop. And, finally, for when you don't want to go it alone, the last section deals with working with a professional photographer.

So hopefully, next time I'm in the market for a house, the agent handling my new dream home will have read this book, and it won't take me another year to find it. Spreading the word about good photography has become my quest, my mission. And, until I accomplish that mission, I will not rest.

OK, maybe an occasional nap.

Recognizing

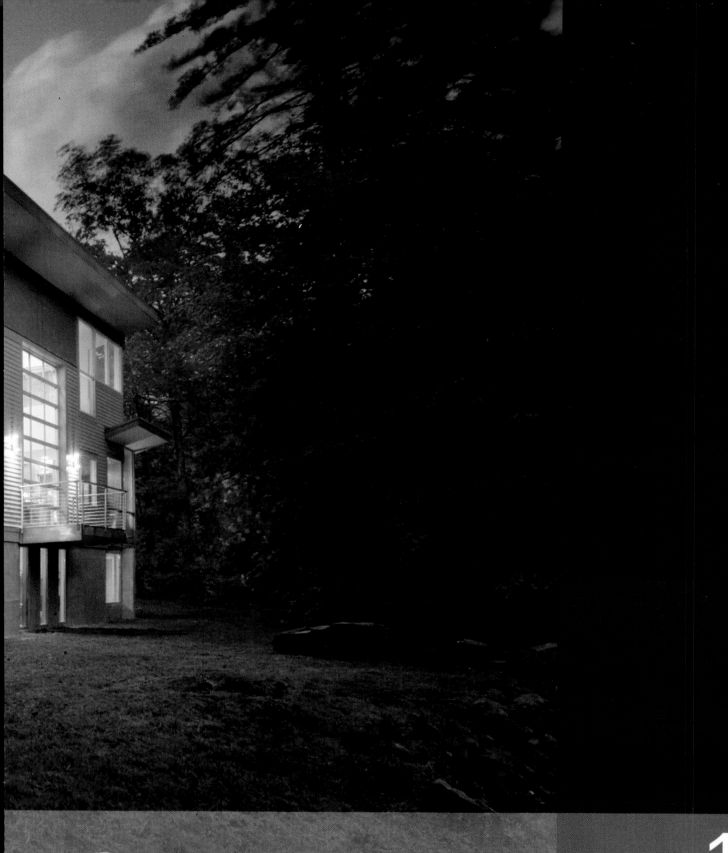

a Good Photo

1

# What Makes One Photo **Better** Than Another?

Back when I was in college, one of my fellow scholars spent the semester in photography class burning photographic paper with a blowtorch, and then developing it to see how it would look. And from what I recall, he got an A and I got a B+. Photography is art, so who's to say that one photo is better than another?

But, we're doing photos for a specific reason. We can pretty much define what makes a photo better for our purposes.

We need our photos to:

> *"Cut through the clutter."* On a real estate web site with thousands of pictures, properties with the better pictures are the ones more likely to be clicked (or at least not ignored).

> *Create a favorable first and lasting impression.*

> *Highlight the unique aspects and features of the property. Photos help the buyer in knowing what to look for (or remember) in a property. A good photo will focus and guide the eye.*

> *Create a mood. Photos don't just show a house, they can create a mood. A bedroom can have a feeling of coziness; a view from a balcony can convey spaciousness; a living room can feel warm and inviting, or elegant and sophisticated.*

> *Show a property in its best possible light (in every sense of the word).*

Think of these photos in the same way as "staging" a house. In staging a house, you try to show a house at its best, emphasizing its most desirable features and creating a "perfect" yet natural-looking feel for a property. Better real estate photos do the same thing.

Let's jump right in and look at a few "before and after" photos. All of these photos and techniques will be explained in more detail later on.

## BEFORE ▶

### The Problem:

The lighting on the house is very "flat," lacking in contrast and color. The sky is washed out. Very boring, not great curb appeal.

**RELEVANT READING:**

Page 96 "The Qualities of Light"
Page 67 "Direct Sunlight vs. Overcast"

## ▲ AFTER

**The solution:** This one is pretty simple. Just by waiting for the sun to be in a better position, the whole feel of the photo was changed.

**BEFORE ▶**

## The problem:

The lighting using the on-camera flash is not real pretty. It's cold looking with harsh reflections and hard shadows.

One of the nicest features of this room is the staircase. Unfortunately, I was not able to move back far enough to get the staircase, the fireplace, and the windows all in one photo.

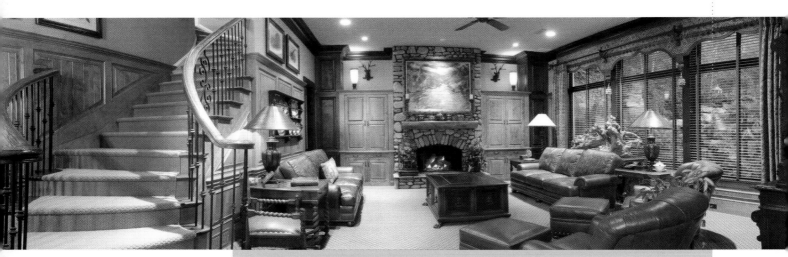

**▲ AFTER**

**RELEVANT READING:**

## The solution:

Put the camera on a tripod and use the available light for a warmer, more natural look.

To get the stairway in the photo, the solution was to either knock down some walls or take several photos and combine them into one "panorama." (The homeowner preferred the latter.)

◀ **BEFORE**

### The problem:

The before photo was taken on a beautiful, sunny day. Perfect for taking beautiful photos, right? Sometimes, but not this time. The bright sunshine caused "washed out" looking areas, combining with the dark shadows to create an overly contrasted, harsh looking photo.

**RELEVANT READING:**

Page 96 "The Qualities of Light"
Page 67 "Direct Sunlight vs. Overcast"

▲ **AFTER**

### The solution:

Patience and a flexible schedule. An overcast day gave a nice soft light to the scene.

BEFORE ▲          ▶ AFTER

### The problem, and the solution:
A challenging situation.
Page 85 "Field Trip"

◀ BEFORE

### The problem:
Sometimes you just can't get the people
and cars to cooperate with you.

▶ AFTER

### The solution:
The camera was put on a tripod,
and a very long exposure (ap-
proximately five seconds) was
used. Although there is just as
much traffic in the "after" photo,
by using a slow shutter speed,
all moving objects have virtually
disappeared!

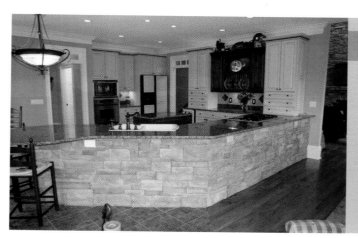

**◀ BEFORE**

### The problem:

Ugh! It's just not working. This photo doesn't make me want to be there.

**RELEVANT READING:**

Page 59 "Composition"

Page 117 "Cropping"

Page 22 "The setting looked great! How come the picture looks like @#$%^?"

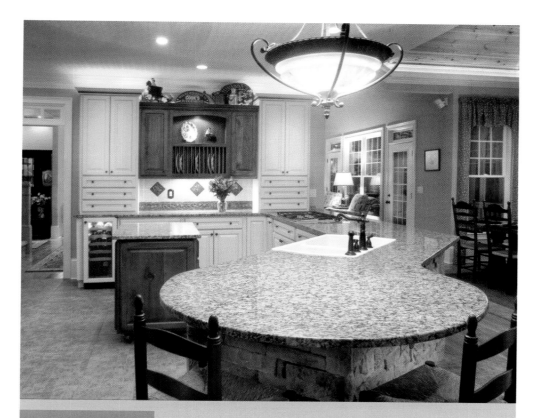

**▲ AFTER**

### The solution:

Here time was taken to scout out the best angle for the photo. The first photo, admittedly, does a better job of showing off the stone facing on the counter, but it's a pretty lousy photo other than that. The finished photo has some interesting lines, good composition, nice light, and gives the room an inviting feel. For a full critique, go to "Composition", page 59.

# The setting looked great!
## How come the picture looks like @#$%^ ?

## Answer: The camera sees differently

> The camera cannot see brightness and darkness as well as our eyes.
> The camera doesn't adjust to different colors of light as well as our eyes.
> The camera does not see in three dimensions as do our eyes.

We see things in three dimensions, the camera sees things in two dimensions. That's why we're surprised to see that the great picture that we took of Aunt Mildred has a lamp post growing out of her head.

Learning to pre-visualize a photo is an ability that we acquire as we learn to pay more attention to what we are photographing and see the results of what we have photographed.

You can train yourself to visualize in two dimensions, as a camera does, rather than three. Closing one eye can help, as we see depth (the third dimension) because each of our two eyes sees the scene from a slightly different angle, giving our brains cues to dimension and distance. With one eye closed, you can still judge depth and distance but you have fewer cues. You then have to rely on:

### SIZE RELATIONSHIPS.
Objects that are closer appear larger (more so when using a wide-angle lens).

### POSITION IN THE PHOTO.
When looking down on a scene, elements that are more towards the top of a scene are usually further away.

### ATMOSPHERIC PERSPECTIVE.
When viewing a landscape, colors far away appear more muted, and less brilliant (less saturated) because of the moisture in the air.

The above cues are present in photos and artwork. That's why even in a two-dimensional photo, we can still recognize relative positions. Training yourself to visualize what the "flattened" image will look like enables you to have more control over the finished result.

The human eye adapts very quickly to a wide range of light and color. A camera only does one thing at a time. For example, if you're sitting on the couch in your living room on a sunny day and glance out the window, your eye adapts almost instantly to the higher light levels outside. A camera, on the other hand, cannot adjust to both light levels at the same time. It can take a good picture of the inside OR the outside. If you took a picture of the couch in the living room, the windows would be overexposed (i.e., too bright). On the other hand, if the windows were properly exposed to show the detail of the outside world, then the living room would show up dark (under exposed).

When we are someplace lit by a single kind of light, our eyes adapt and we don't see any color cast. Wandering around your favorite superstore, you're not aware that, objectively, the lighting may be pretty much the color of a seaweed-based health food drink when compared to daylight. We aren't aware of it though because our eyes adapt. When taking pictures, the camera is depending on us to help it adapt by setting something called "color balance."

In the real world, it's a bit more of a challenge because many times there is more than one source of light. The trick is to know the type of light, the color, the intensity compared to the other light, and how you want the picture to look.

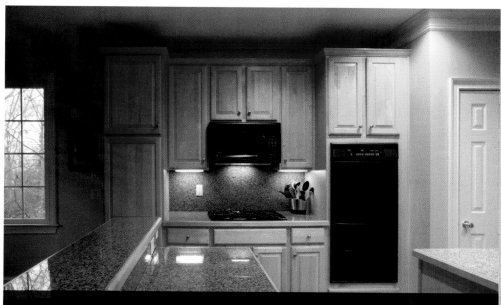

FOR FOUR BONUS POINTS: IDENTIFY FOUR DIFFERENT LIGHT SOURCES IN THIS PHOTO.

For the purposes of illustration, this photo was taken when the outdoor light was not very bright, so that there was no single light source that was dominant overall.

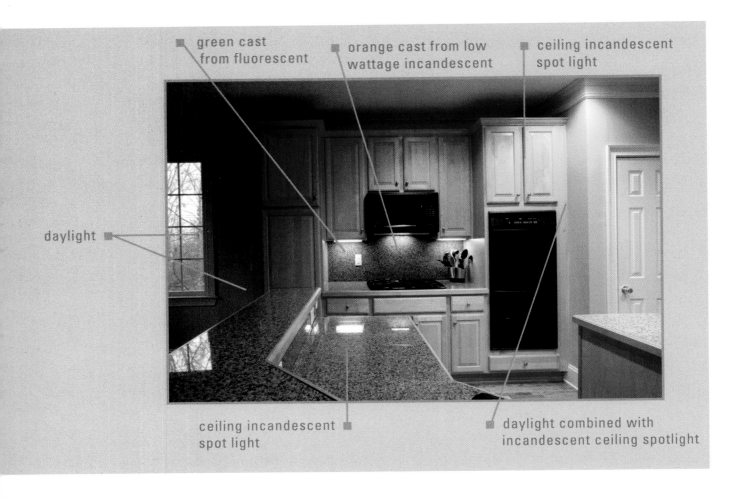

green cast
from fluorescent

orange cast from low
wattage incandescent

ceiling incandescent
spot light

daylight

ceiling incandescent
spot light

daylight combined with
incandescent ceiling spotlight

This kitchen looks relatively normal when you take a quick glance in real life. However, to the camera, the fluorescent light looks green, and the light coming in the window looks blue because it was balanced for interior incandescent light (ceiling spotlights and floodlights).

Is this always a bad thing? Not necessarily. Sometimes combining different color light can make a photo more interesting. Other times, it may detract. (More about this in page 96, "The Qualities Of Light").

Just in case all of the above doesn't present enough of a challenge…if your photo is taken in a poorly lit room, in all likelihood, it will come out blurry.

And if you are depending on your on-camera flash to supply the light, your photo will not look nearly as good as the room does in real life…unless you understand the subtleties of flash.

And if your camera is not perfectly level, the walls, windows, and doors might look crooked and leaning.

# "So, What Can I Do About It?"

*For those of you who don't particularly want to sit down and read this book cover to cover right now, I've put together a list of questions along with short answers and page listings for the more in-depth answers.*

# Just the **FAQ's**, Ma'am...

## ...about cameras and equipment

### WHAT KIND OF CAMERA SHOULD I BUY? page 32

If you can afford it, get a digital SLR (DSLR). If not, a "point-and-shoot" camera can sometimes suffice.

### WHAT'S A POINT-AND-SHOOT CAMERA? page 33

Point-and-shoot cameras are less expensive than SLRs, and more limited in what you can do with them. They are smaller and do not have detachable lenses. This means that you do not have a choice of getting a good wide-angle lens, which is very important when photographing smaller spaces. Most point-and-shoot cameras will not offer the manual control that you can get with an SLR. The image quality is also not as good because of the small size of the sensor. They will do okay in many situations, but are not recommended for serious photography. But they will fit in your shirt pocket.

### WHAT'S AN SLR ? page 33

SLR stands for "Single Lens Reflex." With this type of camera, when you look through the viewfinder you are actually looking through the camera lens. SLRs are more expensive than basic "point-and-shoot" cameras, but will generally give you better image quality. You can also change lenses with an SLR.

### ISN'T AN SLR COMPLICATED AND HARD TO LEARN TO USE?

SLRs have many more features and controls than point-and-shoot cameras. Once you learn how to use one, you will be glad that you did. While you're learning, the camera can be set to the "green" or automatic mode, and work as easily as a point-and-shoot camera.

### CAN I JUST USE MY CAMERA ON AUTOMATIC ? page 35

You can, and in many cases, it will work fine. But, in many cases, it won't. The trick is to know the difference.

### WHAT LENS SHOULD I BUY? page 36

For interior photos, a good wide-angle lens is essential for your SLR. With a point-and-shoot camera, you can't change lenses, although some can use adaptors that will make the lens more wide-angle or telephoto.

### HOW MANY MEGAPIXELS DO I NEED? page 57

The more megapixels you have available, the bigger you can enlarge a photo. Most inexpensive point-and-shoot cameras today have more megapixels than professional cameras had a few years ago. If you get a decent camera, unless you're doing murals and billboards, you probably don't need to worry too much about megapixels.

### DO I NEED A TRIPOD? page 43

Yes.

## SHOULD I USE A FLASH? page 106

A flash can be useful and give great results when used intelligently. It can also make a photo look really bad. I usually avoid using a flash unless it's absolutely necessary. Using just the available light will give a much more natural looking result.

## CAN I USE THE BUILT-IN FLASH ON THE CAMERA? page 106

You can, but I generally wouldn't suggest it unless you're combining the flash with the existing light, using it for "fill."

## HOW DO I GET MY PHOTOS OUT OF THE CAMERA AND INTO THE COMPUTER? page 112

I prefer using a card reader that is either permanently attached or built into the computer. I then drag the images from the card into a new folder that I name with the job description and the date. Do what works best for you, everyone has their own method. There are also programs that help organize photo collections. I'm not the most organized person in the world, but I don't have one of these programs. Or, maybe I have one but I just can't find it.

## WHAT COMPUTER PROGRAM IS BEST, AND WHAT CAN IT DO FOR ME? page 110

Photoshop.

There are other programs out there, but what do I know about these programs? Honestly, nothing. But feel free to explore. Photoshop is usually the choice of professionals, although many pros use specific programs in addition to Photoshop for specific needs. What can Photoshop do? Pretty much anything you can imagine.

## ...about pictures

## MY PHOTO LOOKS TOO LIGHT (OR DARK). page 78

Your in-camera light meter may be getting fooled. Areas that are very bright, such as windows, or very dark, could fool your camera into exposing the entire photo incorrectly.

## SOME AREAS IN MY PICTURES ARE TOO BRIGHT (OR DARK). pages 67, 106, 123, 133

You can use additional lighting to lighten the dark areas, or you can do several exposures and combine them in Photoshop. You might be able to re-capture some lost detail and/or balance the light in a single image by using some of the tools also available in Photoshop, such as the **Shadow/Highlight Adjustment**.

### THE WALLS LOOK CROOKED, WHAT CAN I DO? page 110

You can tilt the camera to make it more level in an attempt to achieve straighter looking verticals. If this is not possible, you can correct this in Photoshop. If all else fails, there's always a hammer and a crowbar.

### MY PHOTOS LOOK YELLOW (OR GREEN, OR BLUE)? pages 23, 82, 98, 102, 114, 132, 135

Learn how different light sources produce different colors of light in photos. Match the camera settings to the light source(s).

### IT WAS A BEAUTIFUL BRIGHT SUNNY DAY, SO WHY DO MY PHOTOS HAVE SO MUCH CONTRAST? page 67

Nice sunlight can be beautiful, but can be difficult to work with if it's coming from the wrong direction. The contrast can be reduced in Photoshop, but another solution is to shoot on a more overcast day.

### HOW DO I GET MY PHOTOS (OR AREAS IN MY PHOTOS) TO LOOK BLURRY (OR TO NOT LOOK BLURRY)? page 52

Photos will look blurry for two reasons. The first is movement, either the camera or the subject. Unless there's an earthquake, it's probably camera movement that is easily solved by using a tripod. The second reason is focus and depth of field. Learning about f-stops will allow you to control depth of field. If your photos are still not sharp, it could actually be that your lens is less than pristine.

### MY PHOTOS LOOK CLUTTERED WITH NO CENTER OF INTEREST. page 59

Use the "rule of thirds" for better composition. Draw attention to an important feature by placing it approximately a third of the way into the photo. We'll talk later about composition and how to attract the eye to a particular feature. We will see how to use lighting, whether done with actual lights on location or afterwards in Photoshop, to guide the viewer's eye.

### MY OLD FILM CAMERA WORKED GREAT, SO HOW COME WHEN I USE THE SAME LENS ON MY NEW DIGITAL CAMERA, I CAN'T GET AS MUCH IN THE PICTURE? page 40

The sensor in most digital cameras is smaller than the film that was used in your old camera. This causes the outer borders of the image to be cropped. Some digital cameras have what's called a full frame sensor. These cameras will give the same wide-angle result as your old 35mm film camera.

**I SPENT BIG BUCKS ON MY FULL FRAME SENSOR CAMERA AND WIDE-ANGLE LENS, BUT WHEN I TRIED TO TAKE A PHOTO, I STILL COULDN'T GET EVERY-THING IN.** page 139

You might consider doing a panorama.

**WHAT'S AN F-STOP?** page 52

An f-stop is a term describing the size of the opening in the lens that lets light through to the film or sensor.

**WHAT'S A SHUTTER SPEED?** page 51

The shutter speed determines how long the light is allowed to strike the film or sensor. It's usually described in terms of fraction of a second.

**WHAT IS DEPTH OF FIELD AND IS IT IMPORTANT TO ME?** page 55

Depth of field determines how much of the image appears sharp, in front and behind the exact point where the lens is focused. It is important because sometimes you want everything in the photo to look sharp, other times you may want to emphasize an area by letting the foreground and/or background go blurry.

The amount of depth of field is controlled by the f-stop that is selected. A smaller opening will result in more depth of field, with more of the photo looking like it's in focus. For all you spectacles wearers, it's like squinting your eyes with your glasses off.

**WHAT'S AN ISO (OR ASA)?** page 50

ISO (and ASA) describe the sensitivity of the film or sensor to light.

Getting

e Equipment

2

# What Kind of **Camera** Should I Get?

Y̶ou may be wondering if it's time to put the old Brownie camera on the shelf next to the bronze baby shoes and invest in something a little more timely. If so, this section is for you.

A BRIEF DISCUSSION OF THE MERITS OF FILM VERSUS DIGITAL TECHNOLOGY AS APPLIED TO THE CHALLENGES OF REAL ESTATE PHOTOGRAPHY
**DIGITAL**.
"WHAT IF..."
**DIGITAL**.
"AND SO..."
**DIGITAL**.
"BUT ON THE OTHER HAND..."
**DIGITAL. NO IFS, ANDS, OR BUTS.**

"WELL, THAT WAS CERTAINLY AN ENJOYABLE DISCUSSION. WOULD YOU CARE TO ELABORATE?"
**SURE.**

1. *Digital offers immediate feedback. No waiting for the lab to process film.*
2. *What you see is what you get. Your photos are not dependent on the skills or lack thereof of the person running the processing machines at your local lab.*
3. *You can do your own post-processing, whether it be in Photoshop or a multitude of image manipulation programs. It's much easier than doing darkroom work.*
4. *Images are immediately in digital form, ready to be printed in a brochure, uploaded to the Internet, or printed on your desktop printer.*
5. *With film, in most cases it would be necessary to have the images scanned to be converted to digital format.*
6. *No film costs.*
7. *It's much easier to get good color and exposure in challenging situations.*
8. *An unlimited amount of exact duplicates of an image can be made for backup, or sharing, with no loss of quality.*

# Types of digital cameras

**SUMMARY:**

Digital cameras are divided into two basic categories:

1. "Point-and-shoot," or "compact" cameras are smaller, less expensive, with a somewhat easier learning curve.
2. Digital SLR cameras are larger, more expensive, but much more versatile, especially when doing architectural photography. DSLRs also have interchangeable lenses, especially important when doing interior photos in smaller spaces where a wide-angle lens is necessary.

## Compact or Point-and-shoot Cameras

Point-and-shoot cameras come in a wide range of qualities. In many instances, they can produce photos that are comparable to more expensive cameras. But for any serious work, I highly recommend investing in a D (digital) SLR.

The viewfinder on a point-and-shoot camera will be either "rangefinder" style, which means that you are looking through the camera using a small window above the lens, or an LCD (liquid crystal display) screen usually on the back of the camera, which shows a digital version of what the camera is seeing. Some cameras offer both.

### Some things to look for in a compact camera:

#### THE LENS
Compact cameras generally have a built-in zoom lens. For photographing interiors, you'll want to get the widest angle lens (shortest focal length) that you can find.

Most compact cameras are pretty useless for photographing interiors because the lenses are not wide-angle enough to show enough of a typical-sized room. There are some camera manufacturers , however, that are producing more wide-angle range cameras.

On a zoom lens the focal length is usually printed on the front of the lens and will say something like 16-40mm. The number that you are concerned about is the first one, the lower the number the better. The second number is the maximum telephoto range, which is less of an issue when photographing properties unless you're just too lazy to get out of your car.

The zoom range of a lens is often expressed in terms of 35mm equivalent. That means the image produced will have the same wide-angle or telephoto look as that number focal length lens on a typical 35mm camera.

I wouldn't even consider any camera that doesn't go below 28mm at the wide-angle end, not that this is wonderful, but you can probably get by with it.

### AUTOFOCUS — GETTING THINGS INTO FOCUS

Autofocus is a wonderful invention, especially for those of us over forty. For general use, it should work fine. But when you're dealing with a low-light situation, or if the point that you'd like to focus on doesn't happen to be right in the center of your frame, it's nice to have the control offered by a better camera, especially an SLR (see below).

Most cameras, SLRs and compacts, allow you to press the shutter button half way down to lock the focus.

### MANUAL MODE

Make sure the camera has a manual mode. That means that you can independently control the f-stop, shutter speed, and ISO (sensitivity of the sensor to light, see page 50). After all this reading that you'll be doing, it sure would be a waste if it didn't.

With some cameras, you can work around the lack of a manual mode by using some of the other available modes, but I'd still highly recommend finding a camera with a manual option.

## Digital SLRs

The digital SLR is the type of camera used by many photographers and serious amateurs. SLR stands for "Single Lens Reflex." That means that what you see through the viewfinder is the same as the image that will be recorded on the chip. The way that this is accomplished is with a mirror that sits in the camera body behind the lens. The light that travels through the lens is reflected by the mirror up into the viewfinder until the instant that the shutter is clicked. At that moment, the mirror swings out of the way, and the light goes straight through to the chip.

### SOME ADVANTAGES OF THE DSLR:

▬ 1. The DSLR is a more sophisticated camera. Most DSLRs can be used in the "green" mode, which means fully automatic, so it will work just like a compact camera but be much

more impressive looking. And, as an added benefit, the images will look better. Plus, when you need the extra control, it is there.

2. Lenses are interchangeable. You can get the best optics to suit your needs. You will be able to get a wider angle lens for a DSLR than you will find on a point-and-shoot.

3. Wider aperture (faster speed lens). The lenses used on a DSLR are noticeably bigger than the lens on a point-and-shoot. A bigger lens allows more light through. This is helpful when working indoors in relatively low light and will also make it easier to get a sharper image in just about any light, especially if you decide to skip the next chapter on tripods.

4. Ability to shoot raw images. (see page 135)

5. Ability to use external light sources. With a professional DSLR, you can use a flash that is not necessarily sitting right on top of the camera. This is useful if you want to have the light coming from a different direction, or if you want to "bounce" the light off a ceiling or a wall to soften it. (see page 106).

6. Choice of using manual or automatic exposure, and manual or automatic focus.

7. Larger sensor means better low-light image quality. Compact cameras generally have a smaller sensor, which means that more information is crammed into a smaller space. This translates to more "noise" at higher ISO ratings, which in English means that when you are taking pictures in low light, the images will look smoother and better defined with a DSLR.

## What's best for my purposes?

If you've got the budget, I would highly recommend that you invest in a DSLR. The bottom line is that you'll have more control, be able to get better images, hopefully make quicker and more sales, and have yourself a great toy! The learning curve is a little steeper, but if you can get through this book, I don't think you'll have a problem. And as I mentioned above, you can always set the camera to the "green" or fully automatic mode, and pretend it's a point-and-shoot while you're discovering it's capabilities.

# What Kinds of **Lenses** Can My Camera Use?

LENSES MAY BE CLASSIFIED AS EITHER WIDE-ANGLE, NORMAL, OR TELEPHOTO.

A wide-angle lens shows more of the scene, with the objects in the photograph looking relatively small. A wide-angle lens is said to have a wide "angle of view."

A normal lens approximates how the human eye might see a scene.

Using a telephoto lens is like looking through a telescope. It magnifies the objects in the scene, but shows a much smaller part of the scene. A telephoto lens is said to have a narrow "angle of view."

How do we describe how wide-angle or telephoto a lens is? By using a number called the "focal length." On a 35mm camera, a 50 to 55mm focal length lens is considered normal. Lenses with longer focal lengths (higher numbers) are considered telephoto, while lenses with shorter focal lengths (lower numbers) are considered wide-angle.

A zoom lens can cover a range of focal lengths.

## Focal Length Defined:

The focal length of a lens is the distance from the optical center of the lens to the film (or chip) when the lens is focused on infinity.

## How Do Photos Taken with a Wide-Angle Lens Look Compared with Those Taken with a Telephoto Lens?

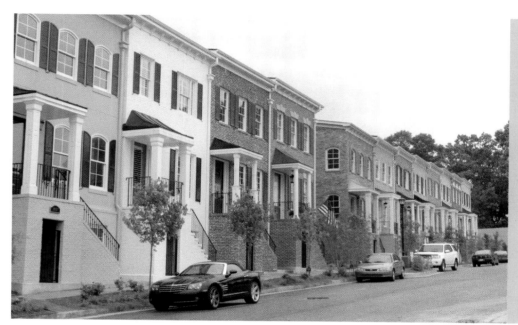

This photo was taken with a 16mm wide-angle lens from a close distance. Note how the buildings in the foreground look much larger than the buildings further back. This is known as the "wide-angle effect."

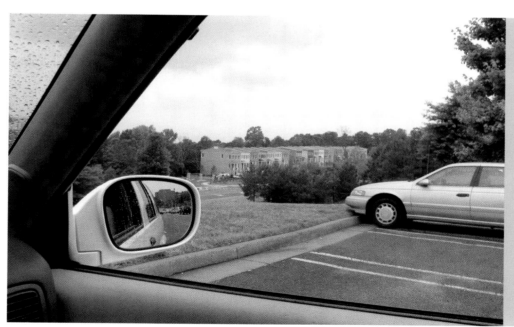

This photo was taken from a much further distance, again with the 16mm wide-angle lens. This is the before-mentioned "too lazy to get out of the car effect.," very convenient as it was raining at the time. If you look at the same buildings, they all seem pretty much the same size relative to each other. Of course, since I am so much further away, they all look pretty tiny.

Now, imagine if we magnified the center part of the image so that all we see is the buildings.

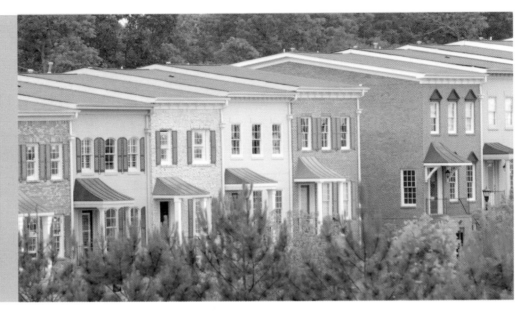

This is what we would get. A photo where all of the buildings look about the same size, but still fill the frame. This is known as the "telephoto effect" and was photographed with, as you might guess, a telephoto lens (200mm).

## The telephoto lens

What exactly is a telephoto lens? Think telescope. It is a lens that has a narrow field of view. In actuality, it is magnifying the center of what would normally be your image. The telephoto lens is sometimes referred to as a "long" lens because it has a long focal length.

A telephoto lens tends to "compress" an image, making it look like things are close together even though there may be a substantial distance between them.

Telephoto lenses are great for many types of photography, but not usually as important for architectural work, especially interiors. If you are photographing people along with structures, a telephoto lens is useful because people tend to look better when photographed with a long lens, and you can blur out a background nicely with a long lens.

A telephoto lens makes it easier to separate the subject from the background by blurring the background.

**MY OPINION, FOR WHAT IT'S WORTH:**

Personally I use Canon DSLR cameras and lenses for several reasons. I find that they work very well with interior lighting conditions, and one of the cameras that I use, the Canon 5D, has a full size image sensor. This means that my wide-angle lens works just like it's supposed to—as a wide-angle lens!

**POP QUIZ:** You've seen it many times in the movies, the cowboy riding off into the sunset (or some variation thereof). The sun looks huge, bigger than a real life sunset, filling most of the frame. How is it done?

*(Hint: You're reading the chapter on telephoto lenses.)*

**ANSWER:** WITH A TELEPHOTO LENS!

The lens magnifies the sun to fill the frame, and the cowboy on his horse is far enough from the camera that he doesn't dominate the picture. This technique is also done with the moon, making it look huge against a normal looking silhouette of a house or other object. Again, the house is far enough away from the camera so that when it is magnified with the telephoto lens it appears to be a normal size house seemingly photographed from a reasonably close distance.

When taking an exterior photo of a house or a building, the right choice of lens can enhance the "curb appeal." A wide-angle lens can make a building look longer, taller, more "stately," and more dramatic. A telephoto lens can bring more architectural details into the photo without these details becoming too small to be noticed. It is also great for zooming in on a particular architectural feature. How do you know which lens to use? Decide what you want to emphasize, and until your pre-visualization skills are honed (and afterwards as well), see what it looks like through each lens.

**SUMMARY:**

Get the widest, fastest lens you can afford.

# Getting by with the minimum

## The wide-angle lens

**WIDE ANGLE ZOOM LENSE ▼**

I could pull out my Christmas wish list of lenses to recommend to you, but I'm going to assume that you don't want to rush out and spend thousands of dollars on these fun but expensive toys just yet. For now, let's look at your basic needs.

When photographing interiors, nine times out of ten, there will be a wall preventing you from backing up the next foot or so to where you could comfortably get behind the camera, and get that perfect angle. What can save the situation from the disastrous possibility of not getting the photo is a good wide-angle lens.

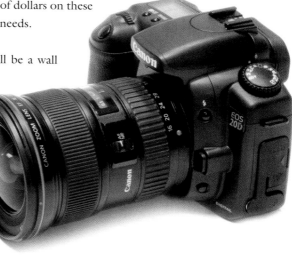

A wide-angle lens is sometimes referred to as a "short" lens, due to the fact that it has a short focal length. It is used when you want to get more subject matter in the frame: top and bottom, left and right.

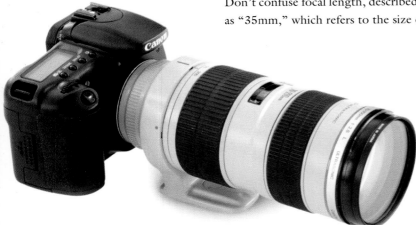

Don't confuse focal length, described in "mm" (millimeters) with the description of a camera as "35mm," which refers to the size of the film used.

Today's professional and "prosumer" (between professional and consumer) SLR digital cameras use a sensor in place of film to capture the light going into the camera. Most digital SLRs generally have a sensor that is smaller in size than a frame of 35mm film. A 24mm wide-angle lens will give a pretty wide-angle of view on 35mm film, but that same lens on a camera with a smaller digital sensor will act less wide-angle and more telephoto. Think about taking that photo done on 35mm film, and then imagine cropping out just the center of it. You loose that wide field of view that you just worked so hard to get.

**▲ TELEPHOTO ZOOM LENSE**

It is necessary to get a wider angle lens to compensate. Many of today's digital SLRs have a focal length multiplier of around 1.5, which means that if you have a 24mm lens on the camera, it will act like a 36mm lens on a film camera (24 x 1.5=36). To get that 24mm field of view as with a film camera, you would have to use a 16mm lens.

Ready for some good news? That problem that we just dealt with, the focal length multiplier, works in our favor when it comes to telephoto lenses. You can get by with a smaller, lighter, and usually cheaper lens, when compared to the lens you would need for a standard 35mm camera.

**MY SUGGESTION:**

If you have a digital SLR, unless it happens to have a "full frame sensor" (same size as 35mm film), get a wide-angle lens that has a 16mm focal length or shorter (smaller number). Your friendly (especially if you just bought your DSLR there) neighborhood photo store salesperson should be happy to advise you if you are not sure.

A zoom lens is a lens that can be set to any focal length within its range. There are zoom lenses that are limited to wide-angle focal lengths, zoom lenses that are limited to telephoto focal lengths, and zoom lenses that span both. Zoom lenses used to provide greater convenience but lesser image quality than fixed focal length lenses. With some of the world's best computer brains spending their nanoseconds designing zoom lenses, this is no longer a major issue. Find yourself a good zoom lens, possibly a 16 to 50mm lens, and make sure that it has a decent maximum aperture (referred to as the speed of the lens). If you find a lens that goes beyond 50mm, still has a decent maximum aperture, and is still within your budget, go for it. If you can, get a lens of the same brand as your camera. If not, there are several lens manufacturers that offer good products, usually at a lower price. (Make sure that the lens mount is compatible with your camera.)

# Don't Forget Your **Memory**

Now that you've made the decision to go digital, you can enjoy not having to pay for film and processing. The digital equivalent of film and processing is the memory card.

I suggest that you take some of that new found money and invest in several good-sized memory cards. Consider that the higher resolution cameras produce images that are larger in file size, and therefore will take up more space on a memory card.

Once you have plenty of memory storage, you can feel free to take plenty of photos, experiment a bit, and increase your chances of producing that wonderful image that will make you the envy of your friends and your competition.

## The Care and Feeding of Your Memory Cards

The last thing you need after spending valuable time taking photos is to find all your work is for nothing because of a memory card error. Here are a few tips to keep your memory cards happy and healthy:

1. Format the card before each use. Or, at least, every once in a while. Formatting is done in the camera, not on your computer, by finding the menu item that says, coincidentally, "format." If you can't find it, as a last resort, read the manual. Formatting will erase all images on the card, so be sure that you have all of your images stored elsewhere.

2. Try not to erase individual images off of the card. Erasing images does not actually erase them, which is a good thing and a bad thing. The bad part is that it may tend to confuse the card and lead to an error. The good part is that, in some cases, you might be able to recover images that you thought were gone forever.

3. Needless to say, keep the cards clean, and not subject to temperature extremes, and all that other common sense stuff.

If you do get an error message, and it turns out that your card has become corrupted, don't panic (see 2 above). If you don't have anything important on the card, you can try formatting the card again.

If you happen to have once in a lifetime photos of Big Foot out for a stroll with Mrs. Foot and Baby Little Foot, or if you've just spent several hours photographing a property, chances are you can recover the photos. This can be done using the software that comes with some cards, or you can get on the company's web site and see what they offer. In extreme cases, you may be able to send the card to the company and have them work on it, or you can try your local camera store.

## Back Up Your Images

Any important images should be stored in multiple locations. You can burn them to a CD or a DVD, put them on a separate external hard drive, or any combination thereof. You can get as obsessive as you like about this. You might consider periodically backing up your files and storing them at another physical location, such as your home or office.

A secret that many people don't know is that most CDs and DVDs are not designed to last forever. Some estimates are 5 to 10 years, although I have CDs that seem to be doing better than that. There are some that are claimed to last for upwards of 100 years...I'm not sure exactly how they know that. Anyway, it's a good thing to keep in mind. Multiple backups on multiple types of media in multiple locations are a good thing.

# The Three Rules of Real Estate Photography: **Tripod, Tripod, Tripod**

## Quick start guide

If you get nothing else from this book, please do this: use a tripod, indoors and outdoors. Experiment a little with shooting at different times of the day and under different lighting conditions. Sure the camera is important, but you know that. What you need to know now is that when you're photographing interiors, a tripod is essential.

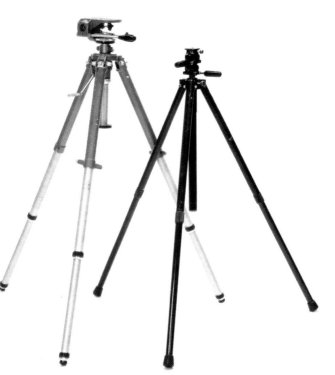

**I'm going to divulge to you an incredible secret:** If you are photographing interiors, in many, if not most situations, you can get great photos without additional lighting, just by putting your camera on a tripod. Of course, knowing how to use your camera, paying attention to composition, color balance, and exposure count…a lot. And, some Photoshop knowledge will take your work up a notch or two. But, once you have a handle on that, you'll be amazed at the quality of photos that you'll be able to produce.

I know that tripods are heavy and a pain to carry around, but in addition to what I said above, here are four good reasons to do so:

**SUMMARY:**

A tripod is essential for indoor photography, and very helpful for outdoor work.

1. Your photos will be sharper. When working indoors, there is generally a lot less light than outdoors. When there is less light, it is much more important to keep the camera steady so that you don't get blur. The brightness level inside a house with the lights on might only be one thousandth the brightness level outdoors! That means that you will be

using a much slower shutter speed, which increases the chance of getting motion blur or camera shake. Using a tripod also allows you to use a smaller aperture, which gives more depth of field (more on this later) with the trade off of having to use an even slower shutter speed (more later on this, too).

▬▬ 2. You will get a better composed photo. When the camera is on a tripod, you can't help but put more thought into the composition and pay more attention to detail, such as making sure the camera is straight and there are no undergarments draped over the sofa.

▬▬ 3. If you are in a situation where the lighting is difficult to control, you might want to make use of Photoshop layers (see page 123). In order to do this, you'll want to keep the camera very steady, so that you can shoot several different exposures that can be layered in perfect registration.

▬▬ 4. Regular tripod lifting is great for the biceps.

# Buying a tripod: The long and the short of it

It doesn't have to be fancy. Not many people will admire your elevated social status of owning a designer tripod. But, it does have to be stable, easy to set up, and easy to use.

You should be able to find something decent in the $150 to $250 range. (Please don't put your thousand dollar camera on a $20 tripod.)

## THINGS TO LOOK FOR:

STABILITY.
This is probably the most important factor. Although a heavy tripod doesn't guarantee stability, one that is too light is pretty much guaranteed to be unstable.

MATERIAL.
Most mid-priced tripods are now made of aluminum or carbon fiber. Carbon fiber is more expensive, but lighter in weight without sacrificing stability.

HEAD.
(The top part of the tripod where the camera sits). The main thing to consider is whether you want a "pan and tilt" head; there are

three distinct locking controls (they point the camera up and down, swing side to side, and tilt the camera horizontally left and right) or a ball head, where one lock controls all movement. Many photographers prefer the ball head, as there are fewer steps involved, but I personally prefer the pan and tilt as it lets me secure and adjust each plane individually. (It's also generally less expensive.)

Consider a quick release head, which makes it easier to put the camera on the tripod and take it off. This comes in handy when changing locations.

### HEIGHT.

Tripod legs telescope to fold into a compact size. You can get a tripod that is shorter when folded up, but the trade off is that there may be more extensions to fool with when setting up. The locking mechanism for extending the legs should be secure, quick, and easy to use. Play with the locking mechanisms to find the method you like; it may be a twist lock or a snap lever.

Geared center posts, where you turn a crank to raise and lower the camera offer more precision, but add more weight, expense, and set up time. Leg braces are not necessary, as a decent tripod will be stable without them.

I use a thirty year old Gitzo tripod (shown on left). It's big, it's heavy, and I could probably use it to jack up my car if I got a flat. But I know that my camera won't be moving.

To go along with your tripod, get a cable release. This allows you to trip the shutter without having to actually touch the camera. Even when on a tripod, you can get camera shake resulting in motion blur when touching the camera with a less than steady hand.

Use a cable release, and go for that café cappuccino mocha latte.

# Buying a **Computer**

Laptop or desktop? A laptop computer is great to have if you are interested in taking it with you out in the field to see your photographic results as you work. Laptops are at the point where they can pretty much replace a desktop computer as far as computing ability is concerned. The downside is that the display screens are not quite as good as a good monitor. However, you can connect a laptop computer to an external monitor when working at home (and a mouse, and a larger keyboard if you like).

Photographic files are usually larger than most files that you are used to working with. Using layers in Photoshop can multiply the size of these already weighty files. With that in mind, consider spending a bit more to get a larger hard drive (for storage of working files), and possibly an external hard drive to store and archive files. A good DVD burner built into the computer (now days standard equipment) is very useful. One way or another, you'll need a way to back up your files.

### RAM

Random Access Memory (RAM) is the memory that the computer uses while doing its processing. To paraphrase an old saying, you can never be too rich, too thin, or have too much RAM. For photographic purposes, 2 gigs of RAM are good, 4 gigs are better.

Apple (Mac) computers are widely used in the photography world. When it comes to color control and consistency, many people feel that they are superior. While not cheap, they are known for being well built, user friendly, and actually fun to use.

Taking the Photo

3

# Camera **Basics**

## What do all those numbers mean?
## ISO or ASA

The ISO, or what some of us used to call the ASA, essentially tells us how sensitive the film or sensor is to light. With digital, this sensitivity can be adjusted electronically. A higher ISO will allow you to get by in dimmer light if, heaven forbid, you are hand-holding the camera. (If you have a quizzical look on your face, please go back to the chapter on tripods!) It will also help to freeze motion; if you are photographing your kid's soccer game on the weekend, you'd want to use a higher ISO (faster) film, or set your digital camera's ISO setting higher.

The disadvantage of the higher setting is that image quality tends to deteriorate as the ISO increases. Detail is "burnt out" or lost in the highlight areas, and shadows tend to get more "blocked up," meaning that areas that should be dark but still have detail tend to lose the detail and go all the way to black. In addition, film grain or digital "noise" (small dots that make the image look rough) tends to become more obvious at higher ISOs. The bottom line: for best image quality, use the lowest ISO that you can get away with. With the camera on a tripod, this should be no problem.

### The Tea Cup Analogy

#### THE LEGEND OF THE F-STOP AND THE SHUTTER SPEED
This little analogy, in one form or another, has become a traditional analogy passed on from generation to generation of photographers.

Let's say you want to fill a teacup with water from a faucet. There are two ways of controlling how much water goes into the teacup. Can you figure it out? Okay, time's up; pencils down.

The first factor is how long you leave the faucet running. This is analogous to the shutter speed on the camera, which determines the length of time that the light is allowed to pass through the lens and onto the film or chip.

The second determining factor is how much you open up the faucet. The variable opening in the faucet is analogous to the aperture in the camera lens, referred to as the f-stop that we described previously.

We can end up with a full teacup of water using different combinations of time and faucet opening. A small opening combined with a longer time or a larger opening combined with shorter time duration can both result in the same full teacup.

The same is true with a camera. Whether you're using an inexpensive point-and-shoot or a professional SLR style camera, the principal is the same. A small opening or f-stop combined with more time (slower shutter speed), can allow the same amount of light into the camera as a wider aperture (larger f-stop) combined with a faster shutter speed.

For those of you with an unquenchable thirst for knowledge, who want to know exactly how those f-stop and shutter speed numbers really work, here's The Professor. For the rest of you… two minute break.

You can observe how the f-stop and shutter speed work together. Point any camera with a built-in light meter (with the camera in manual mode) at a wall or any evenly lit surface. Adjust the camera until you get a "correct" light reading. Change the f-stop one "stop," and then adjust the shutter speed one stop to compensate and bring the light reading back to a "correct" reading. The chart on the next page lists some f-stops and shutter speeds and illustrates how different combinations will yield the same exposure.

Each f-stop number in the chart, and each shutter speed number in the chart, allows one half or double the amount of light through the lens as the number next to it. An f/2.8 allows twice as much light through as f/4. An f/5.6 will only allow half as much light as f/4.

Same with the shutter speeds. 1/250 second will allow twice as much light as 1/500 second. 1/250 second will also only allow half as much light as 1/125 second. Therefore, if you adjusted your camera by one f-stop, you could compensate by adjusting the shutter speed one stop.

If your light meter is indicating that the correct exposure for a scene is 1/250 second at f/5.6, according to the above numbers, you could also set the camera at 1/1000 second at f/2.8, or 1/8 second at f/32, or any of the other combinations above, and you would get comparable and correct exposures.

| f-stop | f/2 | f/2.8 | f/4 | f/5.6 | f/8 | f/11 | f/16 | f/22 | f/32 |
|---|---|---|---|---|---|---|---|---|---|
| Shutter speed | 1/2000" | 1/1000" | 1/500" | 1/250" | 1/125" | 1/60" | 1/30" | 1/15" | 1/8" |

The above f-stops and shutter speeds are fairly standard numbers that have been used on cameras for many years. With newer breeds of cameras with more electronic exposure, you might see many numbers in between those above. Some cameras might have exposure in 1/2 stop increments, some in 1/3 stop increments, and some might have more continuously variable increments.

### WHAT EXACTLY IS AN F-STOP?

An f-stop, when referring to the numbers relating to aperture size, is actually the focal length of a lens divided by the diameter of the aperture. The longer the focal length of the lens, the less light actually makes it all the way down to hit the film or chip. That is why most very long lenses, or telephoto lenses, have as their widest aperture an f-stop with a higher number. For instance, the widest aperture on your 50mm lens might be 1.8, whereas on your telephoto lens it might be 2.8 or 4. More expensive lenses will tend to have a wider maximum aperture (smaller number). This is an advantage not just for low light or action photography, but it also gives a brighter image in the viewfinder. The downside to faster lenses, besides the price, is that they tend to be bigger and heavier.

I SPENT GOOD MONEY TO GET AN AUTOMATIC CAMERA. WHY DO I HAVE TO KNOW THIS SHUTTER SPEED, F-STOP STUFF?

Glad you asked. Your camera can give you a pretty accurate exposure under average conditions. But, unfortunately (or fortunately), it can't think.

 How the f-stop affects the image

Your f-stop controls what areas in your photo will have sharp focus (depth of field).
Your shutter speed determines what will blur from motion, and also allows you to have control over your f-stop.

52 | 53

The f-stop controls what is called depth of field. That means, if you focus on something ten feet away, objects further away and closer will also have a certain degree of sharpness. How much sharpness is determined by the size of the aperture, or the f-stop.

If you happen to wear glasses, take them off, look around, and squint. Notice how things get somewhat more focused? The camera lens works similarly. As the aperture gets smaller, objects on either side of your focal plane (the distance at which you actually focused) will get sharper.

**TIP:** When setting up your photo, decide how much depth of field you will need by looking at the closest object that you want in focus, and then the furthest object that you want to look sharp. A good rule of thumb is to then focus on an object about one third of the way from the front object towards the back object. Then adjust your f-stop. The greater the distance from the close object to the far object, the smaller f-stop opening you will need.

## How the shutter speed affects the image

The choice of the shutter speed determines whether or not you will show "motion blur." Motion blur results from the camera moving or the subject moving. A fast shutter speed will "freeze" motion, while a slow shutter speed will show movement as a blur.

**TIP:** When hand holding a camera, a rule of thumb to avoid motion blur from camera shake is to set the shutter speed at 1/lens focal length or faster. For instance, if you are using a 50mm lens, set the shutter speed at 1/50 second or faster. Telephoto lenses are much harder to hold steady, and therefore require a faster shutter speed. (Remember trying to look at the moon through a telescope, and it seemed to keep zipping by?) According to the rule of thumb, if you are using a 250mm lens for instance, the slowest shutter speed that you can safely hand hold the camera is 1/250 second.

## Better Living Through Technology: automatic or program settings

Some good news for the mathematically challenged. Digital cameras usually have different automatic "mode" settings. The most common:

### APERTURE PRIORITY.
You decide what aperture (f-stop) to use, and the camera automatically sets the appropriate shutter speed.

### SHUTTER PRIORITY.
You set the shutter speed, and the camera sets the corresponding aperture (f-stop).

**NOTE:**

Keep in mind the focal length multiplier of your lens. For instance, if you are using a 200 mm lens and your camera has a focal length multiplier of 1.5, try not to hand hold at a shutter speed slower than 1/300 second, or the nearest available number.

**PROGRAM.**

The camera tries to "guess" the best f-stop/shutter speed combination for you.

**GREEN MODE.**

The camera takes it a step further, sets your ISO setting, and automatically turns on the flash if it "thinks" it's necessary.

You can skim over all the math if you really can't stand it. Just know that when you select a different f-stop or shutter speed, the corresponding shutter speed or f-stop will be changed automatically.

Be aware that if you are selecting aperture priority and using a small f-stop to get more in focus, you might end up with a very slow shutter speed, which could result in "motion blur" if the camera is not on a steady tripod. Conversely, if you are using shutter priority and select a fast shutter speed, you might end up with a large f-stop, which could limit how much of the photo will be in focus (depth of field).

Another mode is *Manual*, where you have total control over f-stop, shutter speed, ISO, and flash.

## ▬▬▬▬ Other Factors That Affect Depth Of Field

The aperture or f-stop is not the only factor that determines depth of field. One factor is how close you are to the subject. If you are focusing on something very close, your depth of field narrows, and things slightly further away will lack sharpness. On the other hand, if you are focusing on something far away, objects that may be quite a distance from your subject will tend to appear sharper. This is why one of the challenges of close-up photography is maintaining depth of field.

Another factor is the focal length of the lens. Telephoto lenses have much less apparent depth of field than do wide-angle lenses. If you are using a zoom lens, the further you zoom out (more telephoto) the more attention you need to pay to depth of field if you're trying to keep things sharp. The opposite is true of shorter lenses. Many photojournalists keep a wide-angle lens on their camera (especially true in the days before autofocus) so that they can be sure that their images will appear sharp even when they are shooting quickly.

Technical:
## DEPTH OF FIELD: THE TRUTH REVEALED

I lied. Sort of.

It is a commonly held belief among photographers that a telephoto lens gives less depth of field than a wider angle lens. It has recently come to my attention that the Photo Techno Geeks (PTGs) out there, (and you all know that I mean that affectionately), the people who for some reason find this kind of stuff fascinating, say that this is not true.

According to the PTGs, if you take a photo from the same position focused at the same distance with different focal length lenses, your depth of field will be exactly the same. It will, however, appear that the telephoto lens has less depth of field because the background relative to the subject is magnified. Although it is actually just as sharp as the background when taken with a wider angle lens if it were comparably sized, because it is magnified, the lack of sharpness is accentuated.

This is why I referred to the "apparent" depth of field above. For all intents and purposes, if you remember that a telephoto lens gives you shallower depth of field than a wide-angle lens, you'll be fine. I just thought I'd bring up this discussion because I think it's kind of fascinating.

Which, I guess, means that I too am a…

Nah, couldn't be

## Resolution: What's a megapixel, and for that matter, what's a pixel?

The megapixel count basically determines how large the image can be enlarged. A few years ago, there was dancing in the streets when the one megapixel barrier was broken. Today, cameras are far beyond that. But, don't get too caught up in it. A sixteen megapixel camera might give you some bragging rights, but unless you're doing double page magazine spreads, it's not necessary. Plus, it will use up a lot of storage space on your computer.

A pixel is an abbreviation for picture element. It is essentially a colored dot (usually a square dot). A megapixel is one million pixels. PPI, pixels per inch, is often confused with but different than DPI, dots per inch, which refers to printer resolution.

Let's take a '**Fantastic Voyage**' into the inner depths of the pixel world.

These four photos illustrate the concept of pixels per inch.

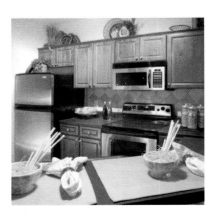

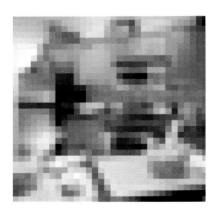

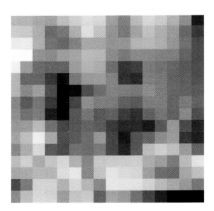

Top left, the image is normal high quality print resolution of 300 ppi. Top right, it has been lowered to a resolution of 32 ppi. The lines on this image are getting jagged. (If we had shown an image at 72 ppi, which is computer monitor resolution, it would have looked a little smoother than the 32 ppi image, but not great.)

At 16 ppi, bottom left, the image is hard to discern. The bottom right image is 8 ppi. You can count the pixels, 16 across, on an image that is 2 inches wide, giving a resolution of 8 pixels per inch. A camera that offers more megapixels essentially will give you an image that can be enlarged more and will give you more detail.

Photos used in print need more pixels for the same size image than photos that are only viewed on a computer monitor. For high quality printing, brochures or magazines, you will generally need in the range of 300 ppi, whereas for computer monitors around 72 ppi are fine. Desktop inkjet printer output resolution is not the same as the input resolution. For good results on an inkjet printer, you'll need about 240 ppi image resolution, which will print well at any inkjet printer resolution.

High resolution images can always be resized to lower resolution and smaller sizes, but you want to avoid starting with a small, low resolution image and making it much larger.

Effective megapixels are those that are actually used to capture the image. Be aware of that when comparing cameras.

Following are approximate images sizes that you can get from different megapixel cameras:

| Max Print Size | Megapixels needed @ 300 dpi (magazine) | Megapixels needed @ 240 dpi (inkjet print) | Megapixels needed @ 72 dpi (Web) |
|---|---|---|---|
| 4"x5" | 2 | 1.2 | Less than 1 |
| 5"x7" | 3.2 | 2.1 | Less than 1 |
| 8"x10" | 7.2 | 4.7 | Less than 1 |
| 8.5"x11" | 8.5 | 5.4 | Less than 1 |
| 11"x14" | 14 | 8.9 | Less than 1 |

**IMPORTANT!!!**

If you need to reduce the resolution of a photo, keep the original and reduce the resolution on a copy.

## Frequent Flyers: Printing hints

For many of you, the most important use of photos is to produce flyers to advertise properties. Generally speaking, you can figure on using a resolution similar to that needed for an inkjet print. For instance, if you are producing an 8½ by 11 inch flyer that has a 4x5 image on it, you need about 1.2 megapixels. (It is only necessary to calculate the size of the photo, not the entire page size.) If the entire page is a photo, then you would need about 5.4 megapixels. It is always better to take your photos at a higher resolution than you think you will need. You can always reduce the resolution later, but you don't want to try to increase the size of a low resolution image.

## The Megapixel Trap

Many people will base their camera purchase decision almost exclusively on megapixel rating. While this is a good starting point, the truth is that image quality is determined by several other factors in addition to the megapixel count. You can get a point-and-shoot camera that has

more megapixels than a high quality DSLR, but except for the short term effect on your bank account, you'll be better off with the DSLR.

Interestingly, more megapixels can actually work against you! In the process of trying to cram more photo diodes (individual light receptors) onto a sensor, the laws of physics reared their ugly heads and demanded that these receptors needed to be smaller. The problem is that smaller photo diodes capture less light, therefore producing worse looking photos! (This is one of many reasons why compact cameras don't produce the same image quality as an SLR: the sensor in a compact camera is smaller.) Unless you're producing murals on a regular basis, stick with the prevailing pixel counts, and don't worry about it.

And, by the way, higher pixel count photos will take up more space on your computer.

 ## Other considerations

### THE LENS OPTICAL QUALITY.

You can have all the megapixels, sensor size, and bit depth in the world, but if the image quality getting through the lens is lousy, the rest doesn't matter. DSLRs will generally win in this competition, plus you have the flexibility of using many different high quality lenses.

### IMAGE COMPRESSION.

Many cameras will automatically compress image files, throwing away data that you might have been able to make good use of. Better cameras will give you the option of compressed JPEG or uncompressed "raw" files.

### COLOR DEPTH OR BIT DEPTH.

If you are doing high quality work look at the color depth or bit depth. Each pixel has a number of color possibilities. Cameras that have a greater bit depth will have better image quality. DSLRs will almost always have better bit depth than point-and-shoot cameras. A typical DSLR will have up to 12 bit depth, whereas less expensive cameras usually have 8. This will be an advantage when working on a photo in Photoshop.

# Composition

Composition is about where things are placed within the frame of the photograph. The placement of the elements in a photo is one of the main challenges to creating great photographs, and while it is a skill that takes some time to develop, there are rules that can give you a head start.

## K.I.S.S.

Keep it simple. A good photo will only include what the photographer wants to show. Accomplish this by first working on the "set." Clean up, hide wires, etc. Make it look good to the eye.

Use the camera to crop out unwanted details. Before you shoot, move around and find a spot where you can get the photo without distractions like fire hydrants, other buildings, cars, etc. Pretend that you're creating a drawing. If you wouldn't go to the effort of including it in a drawing, you're most likely better off not having it in your photo.

## Rule of thirds

Many people think that good composition means placing your main element right in the center of the page and having everything on the left side exactly the same as the right side. This is called symmetry, not to be confused with balance. Sometimes symmetry works well, but as a general rule, we strive for balance. Balance means that the elements on the right side of the page have the same "visual weight" as those on the left side.

The **Rule of Thirds** gives us a guide to getting a nice balanced composition, without resorting to symmetry.

If you take a piece of paper and place two horizontal lines dividing the paper into three equal parts, then do the same vertically, you'll end up with what looks like a tic-tac-toe board. Generally speaking, if you can keep the main element (or any strong visual element) of your photo near one of the lines, or at one of the points where these lines intersect, then you will be on your way to creating a photo with a pleasing composition. From here, you can move the camera around to achieve the balance based on the elements in the photo. Keep in mind that "all

rules are made to be broken." (Does that include this rule, which would then mean that rules are made to not be broken? That's a discussion for another day.) If you are using the **Rule of Thirds** consider it a starting point, and strive for a pleasing balance.

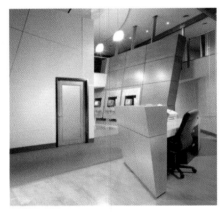

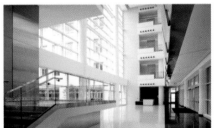

Look at the above photos and note how each has a strong visual element about a third of the way in.

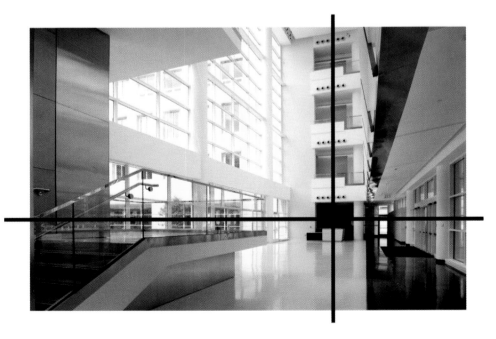

When photographing a landscape, horizon lines usually work well when placed approximately one third of the way down the paper.

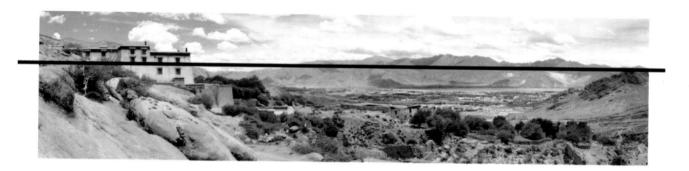

If you're doing a photo where the sky is your most important feature, for instance, a beautiful sunset, you'd do well to put the horizon line on the lower third of the image so that two thirds of the image is sky.

## ▰▰▰ Try different angles

Great photos can present themselves unexpectedly. Look around. Look up, look down. See what different angles look like, for instance, looking down from a catwalk or balcony. Try different lenses, or different focal lengths on your zoom lens. Decide what makes this property unique. Pretend that you're describing the property to someone. Look for the visual elements that illustrate your description.

It is a good idea...no, let me re-phrase that. It is essential to walk around, and look through the camera to find the best angle. Pre-visualizing can make all the difference when it comes to getting a great photo.

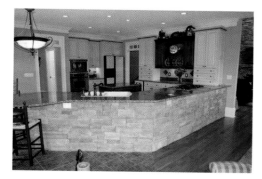
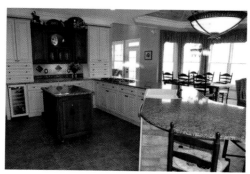

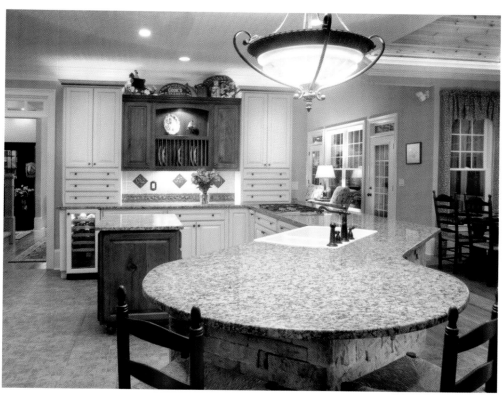

The first photo does a better job of showing off the stone facing under the counter top. But, that's about all it does. The cabinets, refrigerator, and oven look too busy. The composition is unbalanced; the verticals are not straight and make the kitchen appear to be sliding downhill. In general, the photo does not have an inviting feel.

The second photo has a somewhat better composition. It is still "vertically challenged"...the crooked lines cause the counter and cabinets to appear to be suffering from a slight earthquake. The brightness of the windows has fooled the camera's light meter into making the rest of the photo too dark, and the on-camera flash has made the foreground brighter than the background.

By spending a few minutes walking around and looking through the camera, a much better angle was found. The curve of the counter top helps form a beautiful composition, and leads your eye towards the cabinets. Several key elements are positioned using the "rule of thirds."

By waiting until the sun had set, a nice blue outdoor light created a more pleasant effect than the bright, glary windows thirty minutes earlier, as in the second photo. (Tip: If you're going for the blue outdoor look, stay on your toes; there's only about a ten to twenty minute "window" before it becomes too dark.)

Photoshop was later used to straighten verticals, crop out some distracting detail on the right and left sides, and replace detail lost in the bright chandelier and lights above the kitchen table.

Despite all of the above rules and suggestions, recognizing good composition takes practice. Visualizing what a three dimensional scene will look like in two dimensions is not easy, but luckily, digital technology makes it a heck of a lot easier. Take a photo, look at it, take another, see what looks best. You can't beat the instant feedback of a digital camera.

## ▬▬▬ Zoom in on the details

Obviously, if you are creating photos for the MLS and need to show as much of a property as you can in a few photos, you want to squash yourself into the furthest corner with your trusty wide-angle lens. However, if you are producing a brochure or have the opportunity to show a number of photos, details can say quite a bit about the quality and style of a property. This is where it pays to blow the dust off the old telephoto lens and play with different angles.

Here's a photo in a contemporary house, a little plain looking. Our goal was not to literally show the bedroom, but to set a mood, to intrigue. My client suggested that we try cropping in on the photo.

Turned out to be a great solution.

Although this photo was taken with a wide-angle lens, cropping in on the image results in the same perspective as if the photo was taken with a longer (more telephoto) lens.

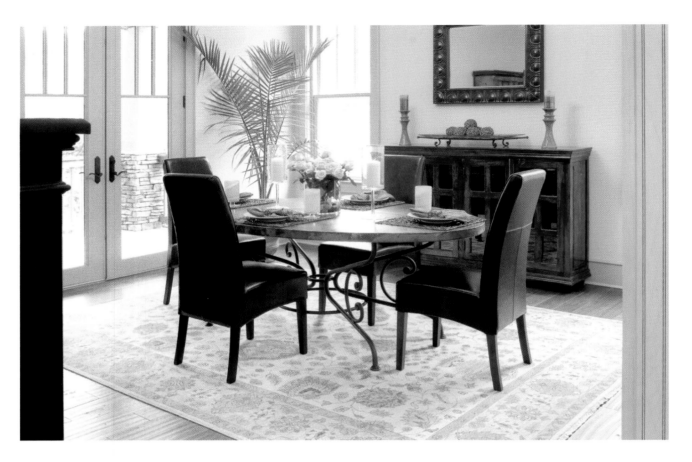

Furnishings can give a feel for the style and quality of a property.

# Existing **Light**

## Direct sunlight vs. overcast light

Even at a lower angle, direct sunlight can interfere with your photos. Sometimes the sun is so bright, or the direction is not great, or there are obstacles such as trees and other buildings that cast not very pretty dark shadows on the building that you're photographing. It can be very difficult to keep detail in the darker shadows at the same time that you are holding detail in the bright sunny areas in a situation with excessive contrast.

What if the building you are photographing happens to face north (or south for our buddies south of the equator) or for any reason just never gets that nice sunlight on it? You certainly don't want to have a photo where the main subject is silhouetted or deep in shadow.

The solution might be to wait for a slightly less clear day when there might be some thin clouds to gently diffuse the sunlight or to wait for an overcast day. In this case, the entire sky diffuses the light, creating soft shadows and a range of tones that is very controllable. In other words, you don't have to worry as much about too bright highlights and too dark shadows.

However, the downside is that your photo might look somewhat flat and boring. On top of that, a cloudy sky filters out the warmer colors (yellows and reds), making the end result looking somewhat cold.

Setting the camera to the "cloudy" setting helps somewhat with the color. But this is a great opportunity to take advantage of the power of Photoshop, where you can adjust the color to whatever looks good, and adjust the exposure and contrast to give the photo more "snap." (More on Photoshop later.)

**TIP**

If you get out to your location and the light doesn't look that great, take a few photos anyway. You may be pleasantly surprised.

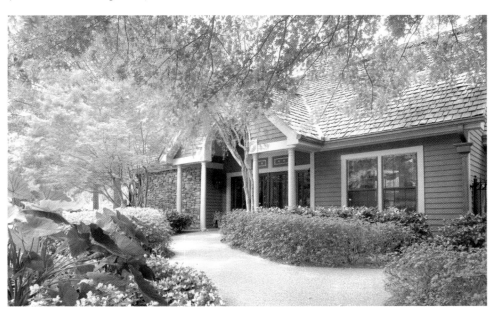

When using Photoshop, it is easier to increase the contrast as you would with a photo taken on an overcast day, than it is to decrease the contrast. A photo with too much contrast may not have any detail at all in the light areas, and this is very difficult to correct. (You can regain some detail with Photoshop's **Shadow/Highlight Adjustment**.)

## Make it Easier For The Camera To Do Its Job

Your camera has a lot of responsibility heaped upon its tiny shoulders. By understanding the camera's limitations, you learn to work within the parameters of your camera's comfort zone and use some of its weaknesses to your best advantage.

Upon arriving at your location, you should first decide what type of light is the dominant light source. If you are dealing with, for instance, a contemporary house with a lot of window light, then that is the starting point. You'll want to use the window light as the main light source, and then you may want to fill in the darker areas with flash or strobe light, which has the same color as daylight.

On the other hand, if the house has nice incandescent lighting, then you may want to wait until late in the day when the daylight doesn't detract from the interior lighting and balance the camera for the incandescent light. You can then fill in dark areas using incandescent light.

## Outdoor Light for Indoor Photos

Daylight is a great light source for interior photos. Using daylight can be a great option if you have sufficient window light and the interior lighting is not a major selling point. Flash is approximately the same color as daylight, which means that if you need to supplement the existing or ambient light, it can be done with a flash.

The photo below takes advantage of the large windows and allows daylight to be used as the main light source. The sunlight is shining directly into the building, making it so bright that the interior exposure balances nicely with the exterior.

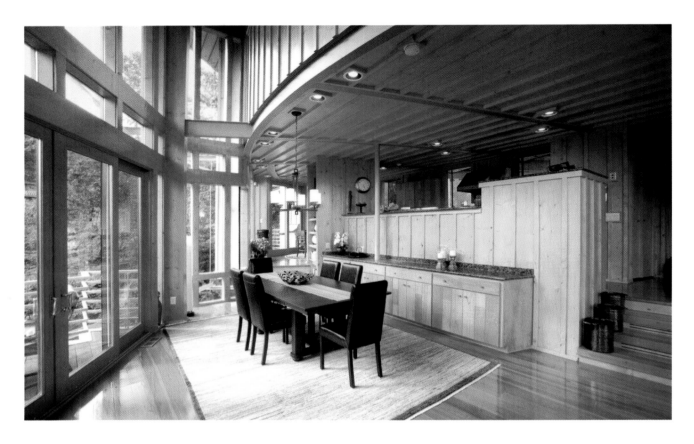

Bright daylight will generally overpower interior lights, so leaving on table lamps or other lighting will not usually adversely affect the final photo. It is usually better to leave lights on than to have them off.

Daylight as the main light works great with contemporary architecture because of the abundance of windows, but can also work great with older architectural styles:

And styles in between:

## More Light Reading

### Inverse square law

The inverse square law is a great icebreaker for parties. Mention it to your new acquaintance, and if their response is that they feel it should be repealed, you might want to wrap up the conversation with a few pleasantries and move on.

The inverse square law is a little technical, but I promise, you'll thank me. Maybe not today or tomorrow, but you'll thank me.

Light loses its strength a lot as the distance between the light source and the subject increases.

**THE INVERSE SQUARE LAW SAYS:**
The intensity of light is inversely proportional to the square of the distance from the light source to the subject.

What this means to you, is that if you are taking photos in a room with a flash on the camera, things that are close to the camera will look brighter...much brighter, than things further away. You may also see this with window light or light from any other source.

### Fascinated? Here's more:

Light loses intensity or brightness as it moves further from the subject. We'll refer to this as fall off. The inverse square law says that the light intensity will change inversely to the square of the distance. If you have a light one foot away from your subject, and then you double the distance to two feet, the light intensity will be reduced not by half as you might at first guess, but by half squared. In other words, the intensity or brightness of the light at two feet will be one fourth what it was at one foot. If the distance was three times, you would have only one ninth the brightness.

So, how do we use this plethora of knowledge? If you're using a flash on camera or other light source, and you find that the objects closer to the camera are much brighter than the objects further away, you may solve the problem by moving the light source further back. If the flash is on the camera, you would have to zoom in with the lens to keep the composition similar. (You can also bounce the light off the ceiling, as described later on.)

As an added bonus, the inverse square law works not just with light but with sound and even radiation. If you want to figure out how close to your computer monitor you can sit before your face begins to glow in the dark, start your calculations with the inverse square law.

## ▬▬▬ "Blue Light" Special

A great way to make a photo more dramatic is to take the photo towards dusk, when the outside light starts to take on a deeper blue color. The contrast of this color with the warm incandescent light color can make the scene much more interesting.

This works especially well with a contemporary structure or any building with a lot of windows. Additional lighting on the outside of this house was provided by a quartz light on a separate exposure. Several exposures were then blended together in Photoshop (more on Photoshop later). For more on how this photo was done, go to www.photosthatmovehouses.com.

In this situation, the court-yard under grey skies was kind of monochromatic. By waiting about an hour, this photo went from this...

**To this...**

Taking the photo at the right moment is very important so that the brightness of the exterior light is where you want it relative to the brightness of the interior. For best results, start shooting before you think the sky is dark enough, and continue taking photos every few minutes after that. Then, in the comfort of home, go through and pick out the best exposures.

Buildings that face north can be a challenge, as the sun never gets to shine directly onto the front.
**A dusk photo can be a solution:**

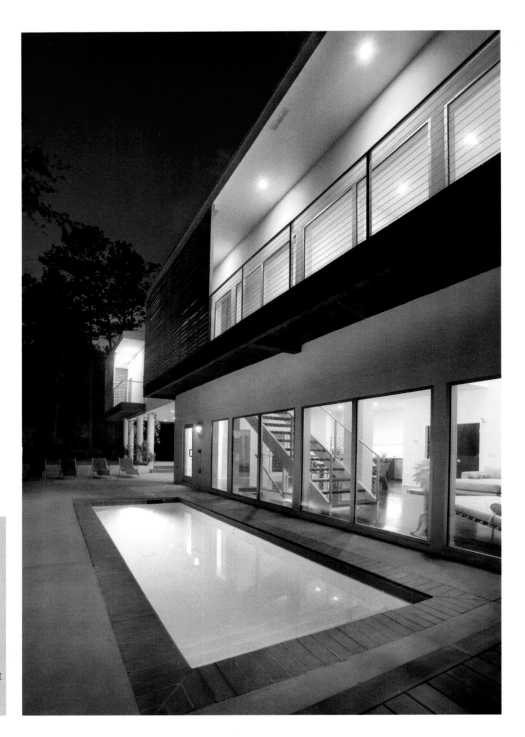

If you are photographing a property that has architectural features that are lit with accent lighting, consider a dusk photo.

When taking several photos, it is real difficult to time it so that you can get all of them with the perfect balance of outdoor and indoor light since the outdoor light is changing, usually more quickly than you would think. Plan out which angle is the "money shot," the best potential photo, and put your best efforts into that one.

If you find that the sky in one of the exposures is perfect, but the outside of the building or the interior looks better in another photo, don't panic. Different photos can be combined on the computer in Photoshop to create the perfect photo if you've taken the photos from the same position on a tripod.

Speaking of Photoshop, here's an interesting example of how two images can be combined into one.

This photo, taken for an interior designer, is lit primarily with the existing incandescent light, supplemented with quartz lights to fill in some of the darker areas. We photographed this at night so that the daylight would not "blow out" (be much too bright) in the windows and affect the interior lighting.

But let's take this a step further.

A separate outdoor photo was taken at dusk with the camera set to the same color balance (incandescent) as the interior photo.

The two photos were combined in Photoshop.

Once again we are taking advantage of the evening cool daylight color, which is seen by the camera as a more intense blue due to the camera being set to balance with the indoor incandescent light.

# Exposure

How do we know if we are getting a good exposure and won't end up with a photo that's too dark or too light? Most of the time, the light meter built into the camera does a pretty good job. But sometimes it gets fooled. For that reason, it's important to understand how the camera "thinks" and how to read the graph that appears on the LCD of many digital cameras.

The graph is called a "histogram" and how they came up with that name I don't even want to think about. A typical histogram will look like a mountain: low on the left and right side, high in the middle.

If you were to take a photo of a grey card, your histogram would be empty except for a vertical line in the center representing all of the grey pixels. If you were to take a photo of a white card, using your in-camera light meter, guess what kind of histogram you would get? Wrong. The camera thinks the world is 18% neutral grey. If it senses a lot of light coming into the camera, as would happen if you were photographing something white, it cuts back on the amount of light it allows into the camera. Therefore, you would have a histogram similar to the one of the grey card, resulting in a photo of what looks like a grey card.

What if you were to take a photo of a black card? Right! It would look the same as the other two photos, because the camera doesn't know that the card is supposed to look black, and keeps the shutter open longer to allow in more light.

If we took a light reading of the grey card, and used the same settings for the white card and the black card (or if they were all in the same photo), then we would have a grey card, a white card, and a black card in the photo. The histogram would then have three vertical lines: the one in the middle representing the grey card, the one on the left representing the black card, and the one on the right representing the white card.

Many photographers carry around a chart with a grey stripe, a black stripe, and a white stripe that they photograph in the same light in which the actual photo will be taken. They then look at the histogram on the back of the camera, and if they see those three vertical lines on the histogram, fairly evenly centered, they know that they have a good exposure.

## HERE'S HOW IT WORKS:

The exposure chart is placed on a light stand in the environment in the same light that the actual photo will be taken.

The camera is moved in close to the chart to exclude any background.

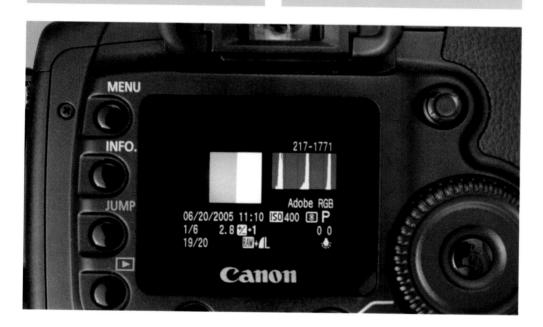

The photographer looks at the histogram displayed on the camera. If the histogram is centered like this one, all is good with the world. If it is off center, or if one of the vertical lines is off the chart, adjustments are made until peace and harmony are restored. The chart is then removed from the set, and the photos are taken.

In general, you want the histogram not to be cut off at either end. When that happens, it means that you are losing detail in the light or dark areas because the image is over or under exposed.

As you look at histograms, you will learn to read them and understand how to control your exposure.

## ▰▰▰▰ Horsing around

To further illustrate the concept of how your camera's light meter thinks, we've enlisted the modeling services of Midnight, our majestic toy plastic black stallion, and Blizzard, our faster than lightning…cow.

Here is a photo of Midnight and Blizzard against a medium grey background:

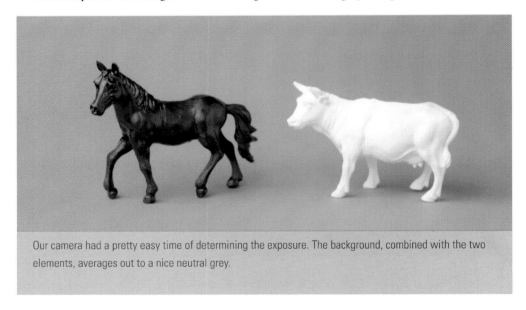

Our camera had a pretty easy time of determining the exposure. The background, combined with the two elements, averages out to a nice neutral grey.

If all subjects were this nicely balanced, we would never have an under- or overexposed photograph. Think how boring the world would be.

What would happen if we decided to photograph Midnight against a black background? The camera's metering system would, with all good intentions, try to lighten the photograph and bring it to its yin and yang balanced neutral state. This is what we would get:

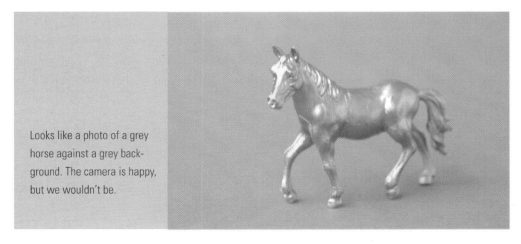

Looks like a photo of a grey horse against a grey background. The camera is happy, but we wouldn't be.

Next we'll try Blizzard the Wonder Bovine against a white background:

Our camera light meter was fooled into thinking that there was too much light, so it compensated by cutting back on the exposure. We ended up with a photo of a grey cow against a grey background.

The key is to be aware of this, and in the case of the white cow, to overexpose slightly to compensate, and in the case of the black horse to underexpose slightly. When you look at the histogram, most of the information on the graph should be towards the right side for the white cow and towards the left side for the black horse.

In real life you probably won't have to deal with this issue much, as most situations tend to be average in tonality. Camera light meters are also now much more sophisticated. But, it is good to understand how your light meter "thinks" so that when you are photographing an interior with bright windows in the photo, or an exterior photo with a bright sky, you'll understand that it might cause the rest of the photo to come out dark because the light meter is compensating for all the bright light. If it's your day off and you are photographing a beautiful sunset, or snow scene, or stage performance (the camera reading the dark background can cause the performers to be overexposed), you'll know to adjust the exposure to get a great photo.

# The **W.A.R.M.E.R.** method

I'M HERE. I'VE GOT ALL MY NEW CAMERA STUFF. **NOW WHAT?**

## The process explained!

Remember playing *Hot and Cold* when you were a kid? As you got closer to your goal, you were getting "warmer."

Creating a good photo is a process, not just a quick snapshot. As you work, things start coming together, you're "getting warmer," getting closer to that moment when you know you've got a great photo.

So, where to start? Here's an overview of the process, all of which will be explained in detail later on. What we need is a way to remember the basic steps. Let's call this, oh, I don't know, how about **The Getting W.A.R.M.E.R. Method!** (Work with me on this!)

### **W**ALK AROUND. WANDER.
Stop and look through the camera. Explore your options. Sounds obvious, but I would bet that most of the time, it's "walk in, glance around, snap a picture." It pays to put some thought into it.

### **A**RRANGE.
Once you've chosen a good angle, move furniture, plants, add a flower vase if appropriate. Clean up, straighten up, work it until it looks great through the camera.

### **R**ATE THE LIGHT SOURCES.
Decide which is the main or "dominant" light source.

### **M**ODIFY THE LIGHT.
If you've decided that the main light source is daylight, open the blinds and reduce any light sources that are interfering. If tungsten is your dominant light, close blinds if necessary, or wait until later in the day. If daylight is dominant, but you think that the photo would be better taking advantage of the tungsten accent lighting, again, wait until dusk or dark.

## EXPOSURE SETTINGS.

Set your ISO, f-stop, and shutter speed.

## RANGE OF EXPOSURES BY BRACKETING.

This means taking the same photo at different exposures: usually two stops up and down in half stop increments works well, much better than going back for a re-shoot.

Change your exposures by varying the shutter speed rather than the f-stop. (See next chapter.)

Check your results on the viewing screen, and congratulate yourself on getting a hot looking photo!

# Applying What We've Learned

If you're a realtor, in most cases you're not going to spend a tremendous amount of time and effort to get one good photo. In many cases, it may be impractical for you to schedule around the outside lighting conditions. The following is an example of how you can take some of the concepts previously discussed and, with minimal effort, get some great interior photos.

## Getting a Property Ready to Be Photographed

I know that you know this stuff, so I'm not going to waste a lot of your time here. To be concise: clean up the toys, vacuum, get rid of the clutter, trim the hedges, mow the lawn, paint, take out the trash, give the kids a haircut, etc.

Depending on your project, it may pay to invest in some "props" such as plants, towels, bookshelf items, etc. It may even pay to hire a decorator or "stager" to bring the look up to the next level.

## A few other tips:

If there's a fireplace, show it with a nice cozy fire. Many times, this will make a great focal point for a room setting.

Turn on all of the lights and/or open all of the blinds and drapes as a starting point. Even if you're using daylight as your main light source, and even if the interior lighting is overpowered by the daylight, lamps usually look best if lit.

# Field Trip!

Everyone bring a dollar and a note from your mother, we're going on a field trip! It's time to take some of the vast knowledge that you've accumulated here and put it to practical use.

A friend recently asked me about doing some photos of her house that was about to go on the market. I suggested that we wait to see what the agent would produce, then I would take a few photos if necessary to supplement.

My thanks to the agent, who agreed to my sharing the photos with you.

Not a bad photo. Could have been better if we could see more of the room.

This was done with the flash on the camera combined with the existing or ambient light. Sometimes this works well, when there are dark areas that need to be lightened, but in this case, it was unnecessary. The light would have been nicer if it were just the ambient light. The trees outside the window prevented the windows from being overly bright. Otherwise, there is a good chance that the overall photo would have been too dark due to the camera's light meter compensating for the brightness.

This is another photo of the same room. This shows more about the furniture than the room.

After wandering around for a while, I decided that an overview would work well and show the relationship between the staircase, the kitchen and the eating area. The camera was on a tripod and only the ambient light was used.

This photo was taken with flash on camera. Here we have a photo of a bed.

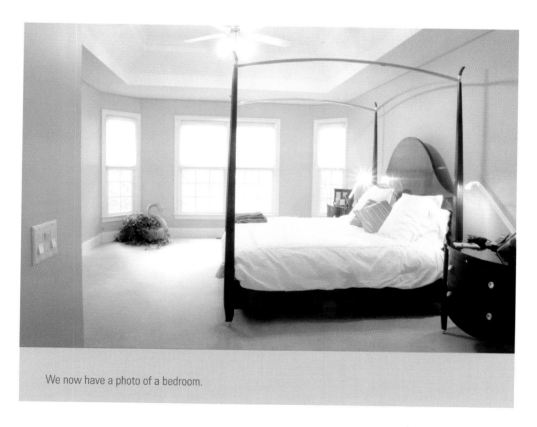

We now have a photo of a bedroom.

Again, the camera was on a tripod and only the ambient light was used. You can see the different colors of the light from the windows compared with the warmer light from the incandescents, but I didn't find it objectionable. Knowing that the bright windows would cause the camera to underexpose, I compensated by overriding the camera light meter, opening up the aperture and allowing more light in. The results were checked by looking at the image on the LCD screen and the histogram.

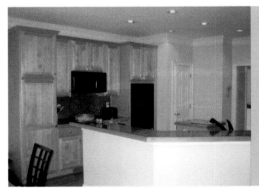

This is a typical flash on camera kitchen photo. Not pretty light. Note how bright and distracting is the white island, partly due to the fact that it's white, partly due to the amount of "real estate" that it takes up in the photo, and partly due to the inverse square law. Note how much brighter this white is than the other white in the kitchen. And the angle itself doesn't give a good feel of the kitchen.

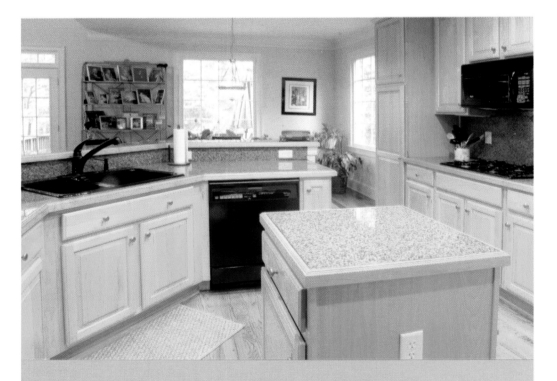

Using the available light, and the camera on a tripod (as in all of my other photos), I got nicer color balance, with more even light (no flash), The composition is more pleasing, and we see more of the kitchen due to the wider angle lens. This photo shows off the kitchen nicely. Again, the color of the window light versus the incandescent is obvious, but tends to enhance the photo by separating the background from the foreground.

Now here's a challenging situation.

I'm not the most organized person. In fact, when I was in college, my room was voted messiest room in the dorm. Unanimously. Two years in a row. And quite frankly, I was proud.

But, when making a photograph that is intended to create a sense of "I want to be there" or, more importantly, "I could see myself buying that house and living there," you need to feed the fantasy.

Spend some time cleaning up and organizing. Even if it looks okay in real life, a photograph is much less forgiving. See the photo on the next page to get the idea.

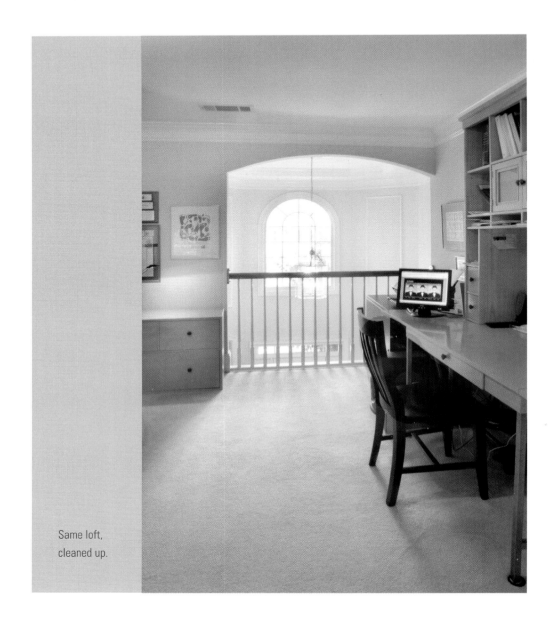

Same loft,
cleaned up.

The unique part of this loft is that it looks over the foyer. I decided to play that up and not show the walls with a lot of personal items.

In this photo, two exposures were combined together in Photoshop because the window area was very bright. It's a great technique to learn, not very difficult, but as of this writing it does require the full version of Photoshop. More on this later.

As an alternative, a flash could have been bounced off of the ceiling to make the brightness closer to that of the foyer. (See the chapter on fill flash.) But the color difference between the

foyer and the overlook (daylight color versus incandescent color) helped to separate the two areas and add depth to the photo. A flash would have made the color of the light in the loft similar to that in the foyer and might not have been as interesting. I got lucky.

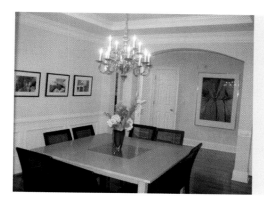

### Moving into the dining room.

The flash on camera results in flat, cold, boring lighting. Note the shadow of the wall on the left.

Looking through the camera on a tripod would have resulted in not having the dining room look like it's leaning.

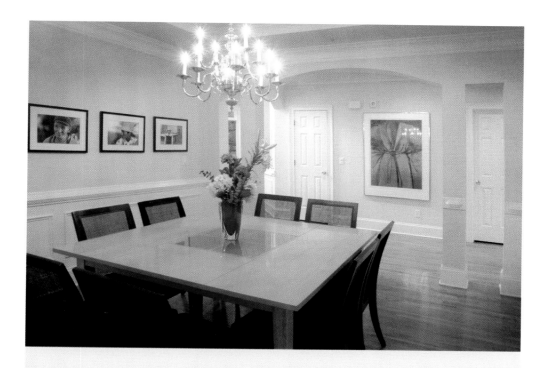

A wider view of the dining room shows off the architectural features, makes the room look bigger, and the warm ambient light is much more inviting.

This photo was taken in the living room, which is a small room, not very architecturally interesting. Aside from that, the camera was "fooled" into thinking that there was plenty of light due to the brightness of the window. The result was that the important part of the room became underexposed. (See page 80 on "horsing around")

Rather than devote time to an uninteresting area and wrestle with boring composition, I looked for other angles that better told the story of this house.

In this photo the difference between the incandescent light in the dining room and the cooler daylight in the foyer was more apparent and objectionable. One solution would have been to light the dining room separately using a flash or strobes. Another solution would have been to wait until evening and have less daylight affecting the color, and then balance the camera to the incandescent light. I chose a third solution: a bit of Photoshop to reduce the intensity of the yellow red cast in the dining room caused by the incandescent lights.

### So what's the secret?
The secret is there's no secret. There's no mystery.

All of my photos were done very simply. I used no extra lighting, no flash on camera. The main difference was that I put my camera on a tripod, and spent some time looking for the best angles.

The tripod allowed me to spend time visualizing and finessing the composition. It also allowed me to use a slower shutter speed, which in turn allowed the use of a smaller f-stop, ensuring that the photo would have more depth of field and be sharp.

Admittedly, my camera has a wider angle lens than the agent's camera. That certainly is helpful, and as I previously mentioned, if taking photos of houses is part of the way that you make your living, I would highly recommend investing in a decent camera and lens.

Photoshop was used minimally. In the loft photo, I combined two exposures together because the window area was very bright. And as mentioned, the objectionable difference in color balance between the dining room and foyer was solved using Photoshop. Other than that, a little brightness, contrast, and color correction here and there was done, but nothing major. (More on Photoshop later.)

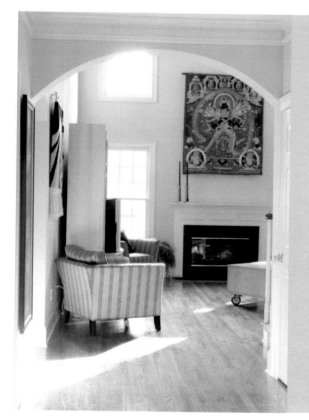

But for the most part, it was a matter of investing some time and thought into the process, and having some knowledge about exposure and color balance. Knowing how your camera "thinks" is important. And, painful though it might be, a willingness to do a little cleaning and organizing can make a tremendous difference. And did I mention, using a tripod? There you go. Mystery solved.

Advanced Techniques

# The Qualities of **Light**

**SUMMARY:**

Different light sources appear as different colors in a photograph.

Daylight is relatively blue, incandescent (tungsten) relatively red/yellow, and fluorescent relatively green.

On daylight film, incandescent light will show up as reddish yellow. On tungsten balanced film, daylight will show up as blue. On either film, fluorescents will show up blue/green, mud, or a variation thereof.

It's better to use the right film or camera setting matched with the right light, and try not to combine different color light sources unless you're doing it on purpose.

There is no film balanced specifically for fluorescents, so filtration is necessary.

If you're shooting digitally, it's much simpler, as you can set the white balance on the camera to correspond with your light source. Using your camera set on automatic white balance might give you satisfactory results, but try setting the white balance to the type of light that you are shooting with, and see if the results are better.

## Who's Lord Kelvin, and what's he got to do with taking pictures?

Many years ago, in the late 1800's a guy named William Thomson, otherwise known as Lord Kelvin, invented what is coincidentally called the Kelvin scale for measuring temperature. The scale starts at absolute zero, the theoretical absence of all heat, when molecular activity almost comes to a halt. This is equivalent to approximately minus 273 degrees Celsius (don't stick your tongue on anything this cold) and works its way up to, well, pretty darn hot.

Having accomplished that, he got bored and heated up a block of carbon (haven't we all been there, done that?!) He noticed that as it heated, the block glowed, with the color of the

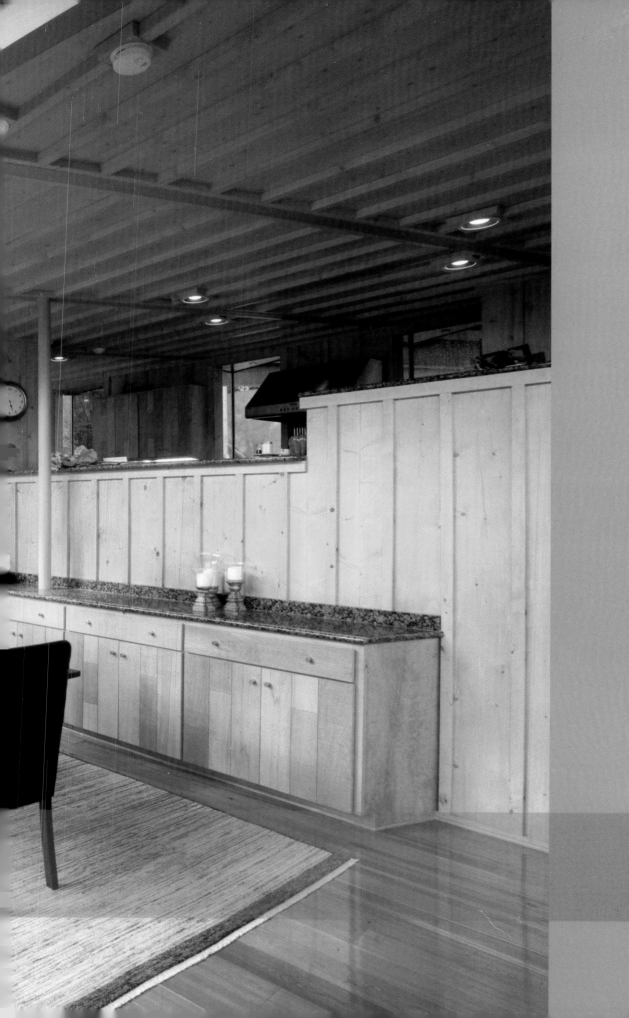

4

glow changing according to the temperature. Not wanting all of that effort to go to waste, he invented a way of describing the color of light with reference to the temperature of the heated carbon block.

In photography, we use this scale to describe the color of light, referred to as "color temperature," ranging from red to blue. To make it a little more confusing, the Powers That Be decided that as the temperature grew hotter, the light emitted from it would be described as "cooler," and vice versa. For instance, at a relatively low (cool) temperature, the object would glow more towards the red end of the spectrum (described as a warm color), and when it approached "white hot" it would glow more towards the blue-white (cooler) end of the color spectrum.

Daylight is usually described as being between 5200 and 5800 Kelvin. However, those of us outside of Seattle know that the color of light changes throughout the day. Depending on the time of day, color temperature can range from a warm 2000 Kelvin at sunrise or sunset, up to 12,000 or even as much as 20,000 Kelvin to describe the daylight from a blue sky.

The flash on your camera is approximately the same color temperature as daylight cloudy/shade, approximately 5700 Kelvin. A typical light bulb that you would find in a table lamp is about 2800 to 3200 Kelvin, halogens are around 3500 Kelvin,

### WHY DO I NEED TO KNOW THIS?

You might come across references to Kelvin temperature in your camera settings, as well as settings in Photoshop such as in the raw converter. Plus, it's part of the wonderful language of color. Just make sure that you say, for example, 3200 Kelvin, not 3200 "degrees" Kelvin, or you might get made fun of by the Kelvin groupies.

## Incandescent

Incandescent or tungsten lighting is the typical artificial light that you find in most homes. Lamps, chandeliers, recessed lights, ceiling and wall fixtures as well as most outdoor fixtures for the most part use incandescent bulbs.

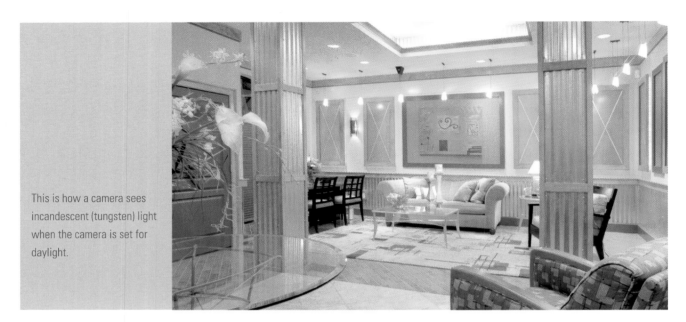

This is how a camera sees incandescent (tungsten) light when the camera is set for daylight.

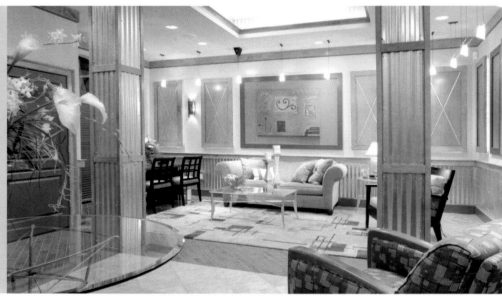

By setting the camera to tungsten balance, the camera records the scene as our eyes see it.

An incandescent bulb creates light by running electricity through a filament that resists the flow of the electricity to a point where it heats up and glows. Incandescent light will appear much warmer (red/yellow) than daylight on film. The color temperature of most incandescent lighting is between 2800 and 3400 Kelvin. Incandescent lights can be controlled by a dimmer, which will not only affect the brightness of the light, but will lower the color temperature (make it warmer or more yellow/red).

Quartz halogen lights are similar to your typical incandescent lights, but are brighter, burn hotter, and have a "cooler" color temperature. (Are we confused yet?)

## Fluorescent

This is how a camera may see fluorescent light when the camera is set for daylight.

By setting the camera to fluorescent balance, the camera records the scene as our eyes see it.

Fluorescent lighting is an ugly animal, photographically speaking. While the human eye adapts to different color light, film or a digital chip is more objective, and may see fluorescent light as having a strong color cast. There are many types of fluorescent bulbs, all with varying colors. It is relatively easy to deal with the color cast from fluorescent lighting, as long as it is not combined with other light sources.

### WHY DO I NEED TO KNOW THIS?

What if you're taking a photo in a kitchen mainly lit by daylight coming in the windows, as well as being partially lit by fluorescents or halogens? Or a living room lit by incandescents, with some daylight coming through a window? You get the idea. The best solution is usually to do what you can to limit the light to one source. Very often it's just a matter of being patient, waiting till evening when there is less light coming in the windows.

Aside from bringing in a ton of lighting equipment, there are other more advanced solutions, such as filtering the secondary light source to match or adjusting colors in Photoshop. If you want to get creative, in the case of tungsten mixed with fluorescents, for example, you can do one exposure with just the fluorescents turned on and the camera set for fluorescent, then do the same with the tungstens, then combine the two images in Photoshop.

Or, just take the photo as is, and it may look great. You don't know till you try.

## Basic Color Theory

Now you've got some good basic information to work with, and with some practice you should see some major improvement in your photos. And since you'll be producing some great photos, I know that you're now acquiring a thirst for photographic knowledge.

This is how color works, when you're looking at your computer monitor, posting your photos on the Internet, or sending your photos off to be printed on flyers or in a magazine:

Computer monitors create colors using the primaries red, green and blue (RGB). This is known as additive color.

Photos that are printed on a printing press use the colors magenta, yellow, and cyan with added black (CMYK). This is known as subtractive color.

Digital cameras photograph in RGB. Photos that are to be printed on a printing press are converted to CMYK.

### Subtractive colors

White light is composed of all of the colors in the rainbow. When white light bounces off of a colored surface, some of the light is absorbed or subtracted. What is reflected creates the color that we see.

Paints, pigments, and colored glass all selectively subtract light.

From the time that as kindergartners we first discovered finger paints, we all learned that the primary colors are red, yellow, and blue, and by mixing paint of these colors together we could produce any color. If we mixed all three together in equal amounts, we were supposed to end up with black. In reality, we ended up with mud.

Years later, some of these kindergartners grew up and decided to invent color printing. Through years of research and endless experimentation, they finessed their knowledge of the primary colors that they learned about in kindergarten. They worked with three primaries similar to blue, red, and yellow: cyan, magenta, and yellow (CMY), and discovered that by precisely combining equal amounts of these three colors, they ended up with, well, mud.

So, they decided to cheat a bit and add a fourth color, black. To avoid confusion, instead of calling it CMYB, they assigned the letter K to black so it wouldn't be confused with blue. The next time you hear about CMYK, that's why. (K actually stands for "Key.")

When you send your photos off to be printed in a brochure or magazine, they will be converted to CMYK for the printing process. When you make a print on your desktop inkjet printer, it is also a CMYK process, but your computer automatically converts your photo from RGB so you don't have to worry about it.

## Additive light

The additive primary colors are red, blue, and green (RGB). When combined as light sources adding to each other, they can create all colors. When combined in equal amounts, they form white.

If you were to have three flashlights, one red, one green, and one blue, and you pointed them at the same spot, they would combine to form white light. Red, green and blue are the additive primary colors. RGB is used in light emitting devices such as TVs and computer monitors. Photos that are used on the Internet remain in the RGB mode, as they will appear on computer monitors. Photos that you take with your digital camera are in RGB.

If you take white light, and break it up into its components, you get a series of colors called the color spectrum; red, orange, yellow, green, blue, indigo, and violet, as in a rainbow. (Insert imaginary obligatory illustration of prism here). If we take these colors and arrange them around a circle, we form a color wheel. Colors opposite each other on this color wheel are called complementary. In photography, if we have an overall imbalance, too much of one of these colors, we can cancel it out by using a transparent colored piece of glass or plastic "filter" in front of the camera lens, or add this color during post processing on the computer.

## Going Grey

Neutral Grey is the Holy Grail of professional photographers. Why, you ask? Because if there is neutral grey in the scene, and looks like neutral grey in the photo, in all likelihood, all of the rest of the colors will be pretty accurate. Who wants their periwinkle pillows to look chartreuse, or their sea foam duvet to scream "avocado?"

HERE ARE FIVE METHODS FOR GETTING THAT ACCURATE COLOR:

▬ 1. **Set your camera's light balance to automatic.** Not always the best method, but gets pretty close most of the time.

▬ 2. **Set your camera's light balance to the type of light that you're using,** such as incandescent, fluorescent, daylight, sunny, cloudy, flash. Again, reasonably accurate, especially if there is no mixed light.

▬ 3. **Put a grey card in the scene.** This is a much more accurate method, especially if you have a genuine photographic grey card (no kidding). "But," you ask, "What good is my photo if I have a grey card stuck in the middle of it?" Ah, a very insightful question, Grasshopper. We're going to do one photo with the grey card, then remove the grey card and do the same photo again.

Later that day, we will go home and open our photos in Photoshop. We will then use Photoshop tools to adjust the color in the photo with the grey card, then apply the same adjustment to the other image. This is a great technique that will be demonstrated in the **Photoshop section**.

▬ 4. There's a wonderful little device called an **Expo Disc** (at left). It goes in front of your camera lens, and by pointing the camera at the light source and taking a picture, (make sure your auto focus is off), it blends the light together, and you end up with a photo of what looks like nothing. But, it's not just nothing, it's colored nothing, that you then use as a source to set your camera's custom white balance (see your camera's instruction manual).

▬ 5. You can also use a white card, grey card, or reasonable facsimile, to set your camera's custom white balance. Again, see your owner's manual.

Personally, I really like the expo disc as the best method. Once I get these images into Photoshop, I find that little correction is needed.

## ▬▬▬▬ What time of day is the best for taking photos?

A common misconception is that the best light for taking photos is bright midday sunlight. This was somewhat true many years ago, when lenses were slower, amateur cameras not as sophisticated, film was not as sensitive, and nobody knew better.

Generally speaking, the worst time of the day for outdoor photography is high noon. The high sun tends to cast ugly shadows, especially on peoples' faces. While this is less noticeable when photographing a building or property, if you can take advantage of a lower sun angle, you will usually get a much more pleasing photo. If you ever notice the better golf course photos, they are almost always done when the sun is low and skimming over the terrain.

Of course, this assumes that your subject property is facing in the right direction. If it's not, the best solution may be to wait for a more overcast day, or at least a cooperative cloud to diffuse the sunlight.

The hour after sunrise, and the hour before sunset, are sometimes called the "magic hour" or the "golden hour," and are considered prime time for many types of photography. The angle of the sun as well as the color of the light are very flattering to people and objects. It's easier to take advantage of this time of day if you happen to be in say, California, or anywhere there is a large flat expanse such as the ocean with no obstructions to block the low sun.

The bottom line: notice how the light changes during the day, consider the direction your subject is facing, take your photo when your subject is shown in its best light. It's a good idea to bring a compass, and try to determine where the sun will be at different times of the day. You might even have to come back a few times until it looks best.

# Adding Light

## Characteristics of Light

When we work with light, sometimes it is necessary to be able to communicate a description of the light that you're working with or would like to be working with. It's also great for understanding light.

### LUMINOSITY
Brightness.

### DIRECTION
Where the light is coming from or going to.

Generally speaking, when lighting a subject the light should come from above, as in nature. Light coming from below, especially on a face, is sometimes called "monster lighting" as you might remember from your childhood when you scared the bejeebers out of your younger siblings by shining a flashlight up towards your nostrils.

## COLOR

If you've been paying attention, you pretty much know what you need to know about color.

## QUALITY

This doesn't mean that the light on Rodeo Drive is better than the light anywhere else on the planet. Quality refers to the hardness or softness of the light, which is determined by the size of the light source and its distance.

A light source that is large will give you a soft light, producing soft shadows because the shadows are filled in by the light coming from different parts of the light source. If you have a very small light source, you will get hard light producing shadows with defined edges.

The distance of the light source will also affect the hardness and softness of the shadows. The further away the light source, the more it acts like a small light source. That is why the sun, even though it is obviously a huge light source, will cast strong shadows. On a cloudy day, the sunlight is diffused through the clouds, and the clouds become the light source. On an overcast day, the entire sky acts as a huge light source, producing very soft shadows.

Back in earlier days of movie making, it was fashionable to photograph portraits of movie stars using very hard light that produced strong, hard-edged, dramatic shadows. Even the movie spotlights didn't produce hard enough light. The solution was to turn the lights around, remove the cover from the tiny carbon arc and use the bare light as the source.

Since that time trends have come and gone, but soft light tends to be more flattering to most people's faces and is used extensively in product and architectural work. Many devices have been invented to change a hard light source into soft light. One basic concept is to diffuse the light by passing it through a translucent material, the size of which determines the resulting softness. The other method is to bounce the light off of a reflective surface such as a large white card, or even a ceiling or wall in the case of architectural work. If we start off with a small light source, one possibility is to bounce it off a ceiling. The light coming down from the ceiling becomes our new light source. This will give us a softer light than if we had just pointed our light directly at the subject.

## LIGHTING RATIO (CONTRAST)

In nature we have one main light source: the sun. If there were no reflection, everything would be lit with bright highlights and black shadows. But since light bounces off of just about everything around us, shadows are lessened.

The comparison between a main light source and the light filling in the shadows is called the lighting ratio. A high ratio gives a dramatic look, a low ratio gives a "flat" look.

When photographing an interior, we might have the window light as our main source. Sometimes we get lucky and, if the walls are light colored and the conditions are right, using just the window light might give us a great photo. Sometimes we might need to lower the lighting ratio because there are dark areas in the room that need to be lightened. We can accomplish this by adding "fill light."

Fill light is simply light that you add to the photo to fill in the dark areas. Here are the main considerations:

**1. The color of the fill light.** The fill light should match the color of the main light. If the main light is window light, then flash or strobe should be used. If the dominant light is incandescent (e.g., if the room is lit with lamps, recessed lights, etc.), then the fill light should also be incandescent.

**2. The quality of the light.** You generally don't want the fill light to be casting its own shadows so ideally the fill light should be soft. If you bounce the light off a ceiling or a light colored wall, then the shadows will be less apparent.

**3. The intensity of the light.** Assuming that you like the qualities of the main light, you don't want to overpower it with the fill light. (If you do, then your fill light becomes your main light, which can be an option.) If your fill light is a stop or so less than your main light, then this will help to avoid showing shadows from the fill light. It will also keep the photo from looking too "flat."

# Fun with Flash

Without a whole lot of effort, you can put a flash on your camera and take some fairly ugly photos. It's easy, and maybe that's why so many people do it. Fortunately, it's also easy to make some minor adjustments and get some pretty acceptable if not darn good results.

A good digital camera will give you several options when using a flash. Many digital cameras will have a flash built in, but it probably will not be powerful enough or flexible enough to give you the results that you need. A good portable flash is worth considering. When purchasing a portable flash, make sure that it is compatible with your camera. Different cameras have different methods of computing flash exposure.

Depending on the settings that you choose, your flash will either overpower all the other "ambient" light in the room or mix with it. Most amateur flash photos are done the first way. This is one of the many reasons why people are disappointed with the way photos turn out. You may be in a room that has beautiful lighting, you take your photo with your on-camera flash pointing directly forward, and the finished photo looks totally different than you thought it would.

Direct flash also has a very harsh look with hard-edged shadows. Why? As we mentioned in the chapter on light quality, you'll have hard shadows when you have a small undiffused light source. Also, the inverse square law comes into play, causing the closer objects to be much brighter than the further ones.

There are diffuser attachments that can soften the light, making the shadows less harsh. Here's another method that can help make your flash photos look better, more natural and more evenly lit. It's very simple and basically involves pointing the flash upwards at a white ceiling. It's called bounce flash.

Better automatic flash units will have a sensor that continues to point at the subject even if the flash head is angled, allowing for the flash to provide an accurate exposure. Some cameras will judge flash exposure through the lens, again allowing for an accurate exposure even if the flash is angled. The bottom line is that you can probably just shoot away and not worry too much about exposure.

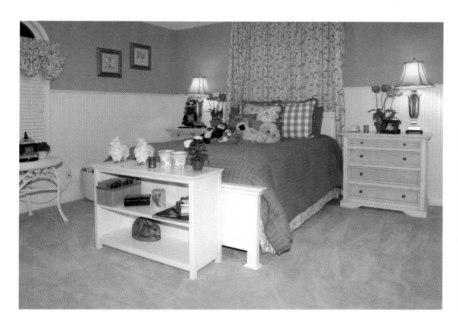

Look at the shadows under the shelves. They are very hard and unnatural looking. This is typical of direct on-camera flash.

The photo above is an example of using direct flash. It's not the worst picture in the world but not real pretty either. You can see how the light is much brighter in the foreground, the foot of the bed, and the bookcase.

Since the foot of the bed was about half-way between the flash and the wall in the background, we can easily calculate by the inverse square law (page. 71) that the background is receiving only about one-fourth the amount of light as the foot of the bed and the bookcase.

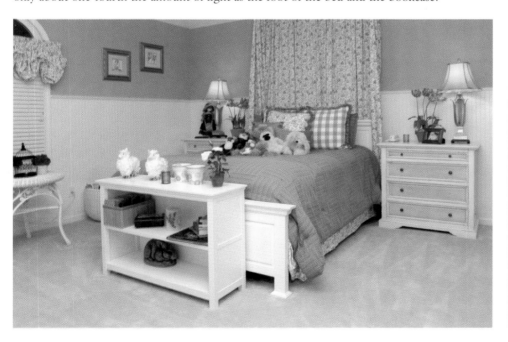

By bouncing the flash off of the ceiling, our light source becomes much softer and the angle of the light becomes more natural since we are used to seeing light coming from above.

With bounce flash, the brightness of the foreground is similar to the brightness of the background, as the light is traveling up to the ceiling then down to the subject.

By estimating the distance the light is traveling up to the ceiling then down to the foreground and comparing it to the distance the light is traveling up to the ceiling then down to the background, we can figure using the inverse square law that the background is receiving about three fourths as much light as the foreground, resulting in a much more even exposure.

## Fill Flash

Here's another simple technique that can make a huge difference. It works by using the available light and then lightening up the shadows with your camera's flash.

Many of today's cameras will do this pretty much automatically. It's just a matter of playing with the different settings…automatic, shutter priority, aperture priority, program…to see what gives you the best result. Here's a demonstration:

Direct sunlight coming through the window gives us a very contrasty looking photo.

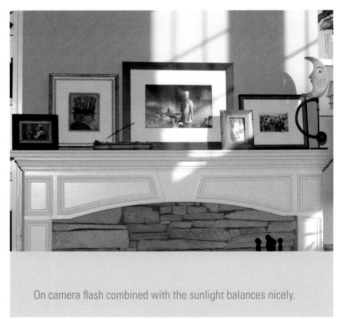

On camera flash combined with the sunlight balances nicely.

## Four Ways Of Using On-Camera Flash

Once that burst of light escapes from the on-camera flash, how pretty or ugly the photo looks may depend on how you have decided to modify that light.

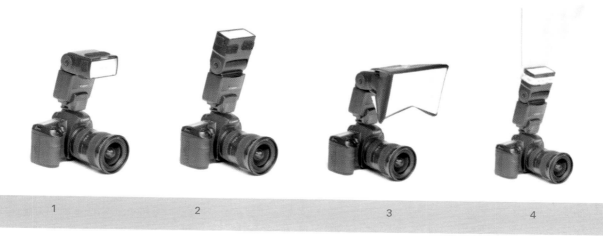

Figure 1 shows the flash in its standard position, pointing forward, as in the first bedroom photo shown previously.

Figure 2 shows the flash pointed upwards, which will bounce the light off of the ceiling, as in the second bedroom photo above. As shown above, this will give us much softer, more natural light.

Figure 3 shows a light modifying gadget similar to a miniature "soft box" (light diffuser). It diffuses the light and creates a larger light source, giving softer shadows. Devices like this are used by many wedding photographers and are especially good when photographing people. They don't, however, solve the "inverse square law" problem of having the background go dark compared to the foreground. Plus, they're not cheap.

Figure 4 is very cool. A piece of white foam core (you can use white cardboard, mat board, or anything else you can think of) is attached to the flash with Velcro. The light from the flash bounces off the foam core, and the foam core becomes the light source...bigger than the original flash, and diffused, creating a softer light. Also, some of the light goes straight up and bounces off the ceiling, creating a much more natural effect. This also is great for photographing people in an environment. (White, reasonably low ceiling preferred.) And, as an added bonus, it's practically free!

# Lighting with **Adobe Photoshop**

We'll get to that in a minute, but first, a brief overview:

Many years ago, just before the advent of Adobe Photoshop, I was invited to tour the facility of a pre-press house where they worked on making color separations (one of the steps in getting photos into print). I was taken to a big white room where temperature, humidity, and dust were controlled, and which housed a very impressive collection of huge computers. It looked like something out of a James Bond movie, with spinning things and flashing lights. The owners showed me a photo of a room interior and proceeded to demonstrate the technological capabilities of the facility by changing the color of a wallpaper border in the photo.

Today, you can do everything that this array of computers was capable of thousands of times over…on your laptop computer with Photoshop.

Photoshop is such an incredible program, it's hard to believe that Thomas and John Knoll, mere mortals, could have created it. My theory is that aliens from another galaxy paid a visit, and not wanting to show up empty-handed, they dropped off the Photoshop code and some cheese Danish, abducted a gas station attendant in Utah, and astral-projected themselves home. But, I digress.

Photoshop requires about a year of experience on a regular basis in order to get comfortable with it. It also costs about six hundred dollars. Adobe, in a selfless display of benevolence, or possibly just good marketing strategy, came out with a simpler, easier, and cheaper (around ninety bucks) version called Photoshop Elements. My advice… for getting started, Elements can do quite a bit. You can always move up to Photoshop later.

Exposure, contrast, and color correction are the basics. Beyond that, Photoshop is great for straightening lines (for instance, when the camera is pointed up or down), sharpening, blurring, removing distractions, and even improving the weather. But what I love most about Photoshop is its ability to save me hours of time that would otherwise have been spent on lighting.

Before we continue let me just say that, as much as I extol the virtues of Photoshop, it is best to do whatever you can in the camera, then use Photoshop to strive for perfection. There is a saying, "garbage in/garbage out." To a large extent, this holds true when it comes to digital photography. Otherwise, you wouldn't have to bother reading all the other stuff in this book. That said, once you've got something decent to work with, Photoshop can work miracles moving it up to next level of quality.

And one more thing. There is no way that I can cover everything that you might want to know about Photoshop right here. If I did, you might get a hernia trying to lift this book. I'll just introduce you to a few concepts, show you some examples of Photoshop's capabilities, and if you have the interest, there are plenty of books on Photoshop out there.

## Learning Photoshop

In general…

When I refer to Photoshop, unless otherwise specified, assume that I'm talking about both Photoshop Elements and the "big" version of Photoshop. This will save me lots of typing, ink costs, and maybe save a tree or two. And I promise the savings will be passed on to you. Also, the following techniques are general and may vary with different Photoshop versions.

**Suggestion:** Skim through the Photoshop manual and tutorials. Most of it won't make sense. Then play with a photo. Then read the manual again. Rinse and repeat.

### RULE #1
Make sure you have enough RAM (Random Access Memory). Insufficient RAM will slow down your computer and cause needless frustration and anxiety.

### RULE #2
Set up your scratch disc (temporary working memory for Photoshop). If possible, this should be on a drive separate from that on which Photoshop and your images reside.

### RULE #3
Use the setting that shows brush size. I can't understand why anyone would want to use a brush that is just a little plus (+) sign instead of being able to see the exact size and shape of the brush. To each his own. At some point you will be tearing your hair out because, even though you set up Photoshop to show brush sizes, it will not show up that way. Hit the "caps lock."

### RULE #4
Don't work on original files. Make a copy of your favorite photo and play. Be careful not to destroy your original!!!

### RULE #5
Play. A lot. Experiment. A lot.

### RULE #6
CONTROL+Z (Undo) is your friend. (COMMAND+Z on Mac.)

## Getting Your Photos Into Photoshop

A very important detail. There are several methods for getting your photos into Photoshop or into your computer in general. The first method is to plug your camera directly into the computer. Your camera will show up as a "drive."

I prefer instead to keep a card reader permanently connected to my computer. When you are done taking photos, turn the camera off, and remove the card. Plug the card into the reader. (Tip: Anytime you connect or disconnect anything from a digital camera or change a lens, turn off the power. But…make sure the camera is not busy writing an image onto your memory card before you shut it off.)

In either method, locate the symbol for the camera or the card. If it does not automatically appear on your desktop, find it on a PC by going to "My Computer." Once you have found it, double click, and navigate until you find the list of photos.

Create a folder on your desktop or wherever you want to store the images. Drag the photos into the new folder.

In Photoshop, go to FILE > OPEN, find the image that you want to work on and double click. You can also go to FILE > BROWSE, and you will see thumbnails of your images. Double click, and get to work.

Do not work on images that are still in your camera or on your card. Make sure that they are copied onto your computer first. It is also a good idea to copy the folder of your images onto a CD or other backup device.

To remove the card on a PC, make sure that the copying of the images is finished, then either go to the **Safely Remove Hardware** icon at the bottom of your screen, or double click to open "My Computer," right click on the icon for the camera or card, and click **Eject.** Then step back! Just kidding. (Nothing will actually pop out; it just disconnects electronically.)

Remove the card, and with the camera off, load the card back into the camera. I highly recommend that at this point you format the card in the camera. This will reduce the chances of having the card screw up during your next photo session.

If, for some reason, your memory card does get corrupted and you can't view your images, don't panic. Do not format the card or do anything that might add to the problem. There are programs on the Internet designed for recovering these files, and some memory cards come with this type of program. You can also call the manufacturer of the memory card, and in some cases you can send the card to them and they can attempt to retrieve the files. As a last resort, there are companies that specialize in data recovery. (If none of this works, then you can panic.)

## Correcting Exposure and Contrast

One thing you'll find about Photoshop is that there are usually several ways to do any task. Some are better, some are easier, but many times they lead to similar results.

To correct exposure and contrast, the simple way is to go to IMAGE > ENHANCE > BRIGHT-NESS AND CONTRAST. In previous versions of Photoshop, this method used to give very little control over the adjustments. If you were a professional photographer and used this method, the photography police would have knocked down your door and confiscated your khaki cargo pocket pants. In newer versions of Photoshop, it's much improved. However, the two best methods are **Levels and Curves.**

**Curves** is a little more difficult to master, but essentially allows you to adjust the brightness of individual areas.

**Levels** is an adjustable graph or histogram showing how many pixels of each brightness tone there are in the photo. Photoshop will show a histogram similar to the one that you may see on the LCD on your camera. We talked about histograms earlier, but to refresh your memory, a histogram shows how many pixels of each tone or level of brightness there are in your photo.

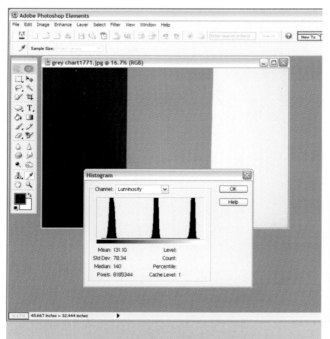

This screenshot shows the histogram for a grey chart. The vertical line on the left represents the dark stripe, the middle vertical line represents the grey stripe, and the vertical line on the right represents the white stripe. This histogram is essentially the same as the one that you would see on the display of your digital camera.

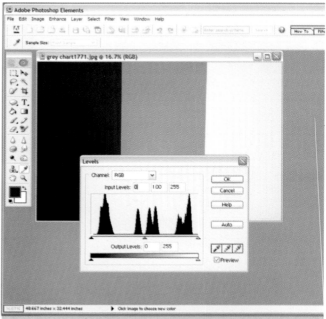

In "Levels," there are sliders underneath the histogram.

The left side of the **Levels** histogram shows the dark tones, the right side shows the light tones. If you move the left slider to the right so that it comes into the histogram you are essentially darkening the dark areas, and if you move the right slider to the left you are lightening the light tones. If you do both, you are increasing the contrast. Be careful when doing this because if you come in too far you are throwing away valuable information, making dark areas block up or go black and making light areas "burn out."

There is also a middle slider which controls the middle tones. Moving it to the right makes the image darker, moving it to the left makes the image lighter.

## Correcting and Enhancing Color

Most of the time, using the color balance settings on your camera will get you real close and no further adjustments are necessary. Sometimes it gets trickier.

The best way of correcting color is to have some reference in the photo or a test photo that you know is supposed to be neutral grey. A grey card works wonders for that

One simple method is to use the middle eye dropper in the **Levels Adjustment** (see above), then click on the grey card, or if you didn't use a grey card, try to find an area in the photo that should be neutral. If you don't like the color once you've done that, you can keep clicking in different areas until you get results that you like.

You can take this a step further by creating a **Levels Adjustment Layer**, and then use the middle eyedropper. The advantage to this is that you are not affecting the original image, plus, if the adjustment is too strong you can lower the opacity of the layer. (More on Layers later.)

You can always go to IMAGE > ENHANCE > COLOR and use those controls, either on their own or after you use the previous method.

## Going for the Grey

I mentioned earlier a technique for getting balanced color where we included a grey card in the scene, then took another photo without the grey card. (The two photos don't have to be exactly the same, as long as the lighting is similar). You can get a pretty good color balance by creating a **Levels Adjustment Layer** using the middle eye dropper and clicking on the grey card in the image. The goal is to move the color correction from one photo to the other.

### HERE'S HOW
Open the first photo with the grey card. Sample photo (next page) has a blue cast. Color casts occur due to the color balance being incorrectly set on the camera, the sensor fooled by other light sources, paint colors, or by mischievous gremlins.

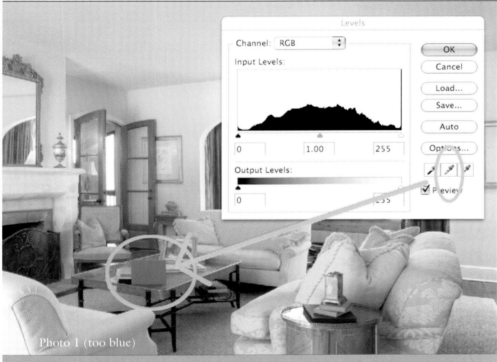

Photo 1 (too blue)

Go to LAYER> NEW ADJUSTMENT LAYER > LEVELS. Notice the three eyedropper icons? Choose the middle one, and then click on the grey card. (See result on next page.)

Look at the **Layers Palette**. If it's not there go to WINDOW > LAYERS and you'll see a layer called **"Levels."** This is the correction layer that was automatically created when we clicked with the levels eyedropper. Do not close this photo. Then open your second photo, the one without the grey card. With both photos visible, go back to photo number one. Click and drag the **Levels Layer** to photo 2, and let go.

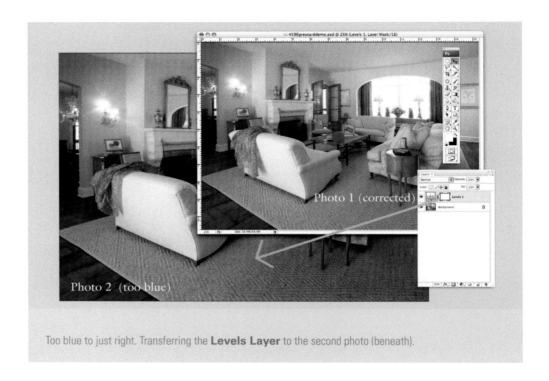

Too blue to just right. Transferring the **Levels Layer** to the second photo (beneath).

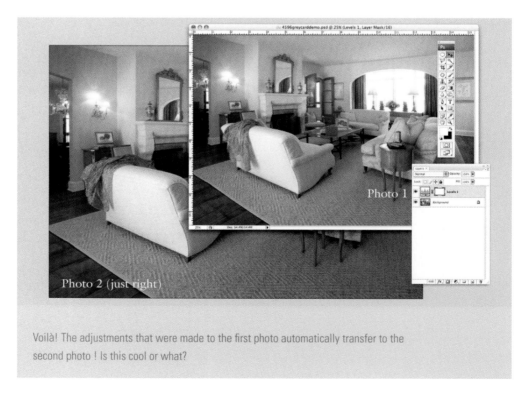

Voilà! The adjustments that were made to the first photo automatically transfer to the second photo ! Is this cool or what?

## NEXT METHOD:

Let's bring this to the next level (no pun intended). If your camera can take raw images (see chapter conveniently named "Raw Images"), color adjustment can be easier, more accurate, and can you believe it, even more fun!

Using Photoshop's **Raw Converter**, open the image, experiment with the different color settings, or use the **Eyedropper Tool** on the grey card. Once you like the results, choose "**Previous Conversion**" for your other images.

If you forgot to bring along your grey card, you can do the above by finding an area in the photo that looks relatively neutral. Use the **Eyedropper Tool**, and click different areas until the photo looks good.

116 | 117

## Cropping

If you always use your tripod, you will generally have the composition of your photo figured out before you get home and bring it into Photoshop. However, there will be times when you look at the image on the computer screen and realize that it could have been moved over a little, or there's too much sky, or you don't like the car bumper that's just starting to appear on the edge. Or, you might have to fit your rectangular photo into a square space.

The **Cropping Tool** is the one that looks like a pound sign that's put on a few extra pounds. The symbol is based on cropping L's, which are L shaped pieces of board that photographers have traditionally used to help visualize potential crops either on a Polaroid, a print, or a transparency.

When using the **Cropping Tool**, the first option is to crop "free-form" where you click inside your image and drag until you have a crop that you like, then hit the "enter" key. If you have a specific size that the finished image needs to be, type in your numbers in the **Width** and **Height** boxes. This will give you a result without re-sampling your image, which means that no pixels will be added or thrown away.

If you need your finished image to be a specific size and a specific resolution, fill in all three fields. However, be aware that if your original image did not have enough pixels to result in the size image that you specified at the resolution you specified, Photoshop will fill in pixels to arrive at that size image. This is called interpolation. Conversely, if your original image has more information than is necessary for your final crop, Photoshop will throw away information. This isn't necessarily a problem unless you plan to use the same image again at a larger size. The rule of thumb is to always keep your original image someplace safe and do these adjustments on a copy.

## The Amazing Clone Stamp Tool

According to all the major polls, this is the most fun tool in Photoshop. With the **Clone Stamp Tool**, you can add a third eye to your boss's face and probably not get fired unless he happens to be looking over your shoulder. What this tool does is to pick up information from one area and place it in another area. It is great for covering up those ugly yellow spots from the Schnauzer on the front lawn, and other uses way too numerous to even attempt to mention.

Select the **Clone Stamp Tool** and find an area in the photo that you would like to duplicate elsewhere. ALT+CLICK (OPTION+CLICK on a Mac) on this area. Now move the mouse to where you want to put this information. Click, hold, and paint. Watch the + sign to see where the **Clone Stamp Tool** is picking up information, as it will move as you move the mouse.

Photoshop has two other tools that are more sophisticated versions of the Clone Stamp Tool: the **Patch Tool** and the **Healing Brush Tool**. These tools clone but also take into consideration the underlying image.

## Getting Things Straight

One of the clues that a photograph was not done by a professional is when the structure appears to be leaning or on the verge of collapse. Not a great selling point. You need to keep the vertical lines straight.

When you look up at a tall building, the vertical lines seem to come together towards the top. This is called convergence or perspective. This is not necessarily bad. It can dramatically emphasize the height and "power" of a structure when used properly. In most cases, however, architectural photos look best when the vertical lines are straight and parallel.

Back in the old days, architectural photographers almost exclusively used what is called a "view camera." These cameras look like the old-fashioned cameras that Matthew Brady, one of the original paparazzi, lugged around on his back while chasing Abraham Lincoln trying to get a photo to sell to whatever was the 1800's version of the tabloids.

View cameras are still very much in use today, but one of the main benefits of the view camera, perspective correction, is available in Photoshop. This is important unless you are purposely going for a dramatic perspective effect. If you are photographing an interior, for instance, you almost always want the vertical parts of the walls, doors, windows etc. to be straight. If those

elements are a little off vertical, it will appear to be a mistake.

With a typical camera, the only way to keep vertical lines straight is to have the camera perfectly level. This of course limits your freedom when it comes to composition.

The following photos demonstrate how the tilt of the camera can cause the vertical lines of a building to appear angled:

This photo was taken with a wide-angle lens, with the camera level.

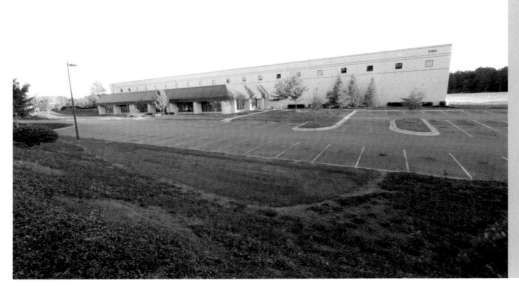

By tilting the camera down, the vertical lines become skewed.

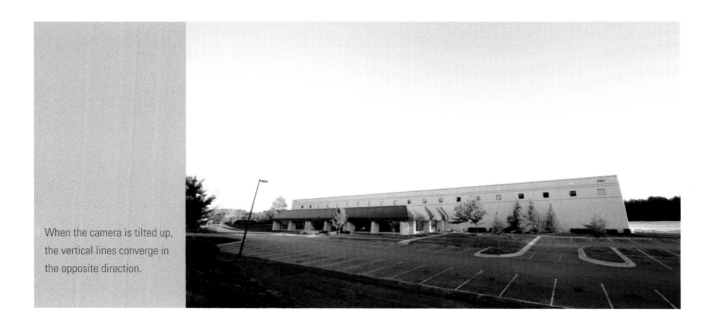

When the camera is tilted up, the vertical lines converge in the opposite direction.

On a view camera, the front and back parts of the camera (called the "standards") are designed to "swing," "tilt," "rise," and "fall." By tilting the rear standard, it is possible to correct the apparent convergence. (The front standard is used to control what will be in focus.)

Here's what happens when you have the camera tilted down. This is sometimes necessary in order to show the furniture from an angle other than the perspective of a four year old.

## THE SOLUTION:

The way to duplicate the effect of the view camera in Photoshop is to SELECT > ALL, then select EDIT > TRANSFORM, then choose either "PERSPECTIVE" or "SKEW."

Grab a corner, and move it to see the results. Keep in mind that when you are done, you will have cropped out some of your image on the ends, so if you know that you will be doing this, shoot a bit loose.

## A Barrel of Fun

Barrel distortion is no laughing matter when you're trying to get your lines straight. When using a very wide-angle lens, the vertical and horizontal lines may curve outwards in the center, which apparently reminded someone of the shape of a barrel.

The opposite of barrel distortion is called pincushion distortion. Personally, I have never seen a pincushion in that shape, but I'll withhold comment for fear of showing my lack of "home-ec" expertise.

Photoshop (big, expensive Photoshop) comes with a filter that corrects lens distortion problems. Maybe "little" Photoshop (Elements) will follow in its big sibling's footsteps.

Continuing with the previous image, it looks pretty good but now there's a bit of "barrel distortion." Shall we keep going? Sure.

Go to FILTER > DISTORT > LENS CORRECTION. Move the slider that says "**Remove Distortion**" slightly to the right and watch the curved walls straighten up. To make it easier, a grid is provided at no extra charge.

When you like what you see, hit enter, and then crop the image to remove the blank areas on the edges of the photo.

There is a lens called a PC, or perspective correction lens, available for many cameras. The way that this lens works is it shifts up or down similarly to how a view camera would shift the front standard. If you do a lot of architectural photography, it may pay to look into getting one of these, but for now, the Photoshop fix should be sufficient.

## And Now, as Promised, Lighting with Photoshop!

Now that you're familiar with some of the basics, here's how we can put them to use instead of carrying around a truck load of lighting equipment.

### PHOTOSHOP LAYERS...YA GOTTA LOVE 'EM!

**Layers** is probably the most powerful concept in Photoshop. Imagine having a photo, then putting clear plastic pages on top of the photo. Now imagine that you can draw on these pages, adding more imagery to the photo. Or, you can add type or another photo, and be able to resize each one individually. You can even change the transparency of whatever is on that page, adjusting how visible it is on top of the original photo. That's the x-treme basic concept behind **Layers**.

Now imagine that these plastic pages are magical, and by putting one of these pages on top of your photo you can lighten the photo, darken it, or change the color. You can do all this without using **Layers**, but if you use **Layers**, you can undo it easily, as well as change the amount of the effect or the part of the photo it affects. These **Layers** are called **Adjustment Layers**.

Here are two methods of using **Layers** in Photoshop to make a photo look like you've spent hours working with your best lighting techniques. In Photoshop Elements, you can use **Layer Masks** on **Adjustment Layers**, but not on other types of **Layers**, such as those you'd create by putting one photo on top of another. To start, we'll look at what can be accomplished in Photoshop using **Layers**.

## METHOD 1 (FULL VERSION OF PHOTOSHOP ONLY)

This technique is very powerful, allowing you to create a photo that looks like you've spent hours lighting the set. However, only the full version of Photoshop offers the **Layer Masks** feature necessary for this technique, which in my opinion justifies the upgrade. In this section, or any section involving **layer masks** Photoshop means Photoshop. (Photoshop Elements does provide **Adjustment Layer Masks.**)

This method involves planning ahead, doing several exposures of the same scene, with the camera firmly planted on a tripod. Try to use the same f-stop in all of the photos, as changing the f-stop might cause each image to be slightly different. To accomplish this, do all exposure adjustments using the shutter speed. Go up and down with your exposures as necessary to capture detail in the light and dark areas. Three exposures worked in this case to keep detail in the dark areas as well as the bright window.

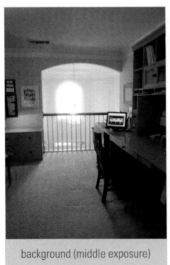
background (middle exposure)

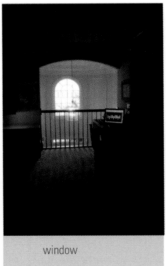
window

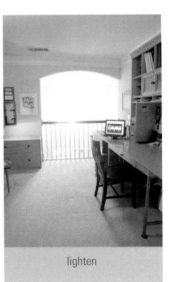
lighten

We open the middle exposure photo in Photoshop, and then bring in the darker and lighter photos by opening them, then dragging them on top of the main exposure while holding the SHIFT key to keep the photos "registered" correctly or in the exact same place.

Each time that you drag another photo on top of the main photo, it automatically becomes a **Layer**.

Go to LAYERS > ADD LAYER MASK > HIDE ALL.

For organizational purposes, you can double click on the **Layer Name**. (If you don't see the **Layers Palette**, go to WINDOW and make sure in the drop down menu that **Layers** has a check mark next to it. If not, click on it.) You can now rename the **Layer**, calling it, for example, "window" or "lighten."

## STEP 3

You will see a black box next to the **Layer Icon**. This is your **Layer Mask**. When it is white, you can see the new **Layer**. If it is black, the effect of the **Layer** is blocked. If you use any of the painting or drawing tools to paint white on the **Layer,** wherever you paint will allow the effect of the **Layer** to show.

You can also fill the **Layer Mask** with white or black. Click on the **Layer Mask**, then go to EDIT > FILL, then select USE-BLACK or USE-WHITE.

## STEP 4

Choose a brush from the **Toolbox**. If you look at the top of the screen, you'll see where it says "brush" and a number. The number is the size of the brush, and the black circle next to it shows the shape and whether it is a soft or hard brush. For most of what we're doing, we'll want a soft brush of medium size, which you can check by looking while you move the mouse over the photo.

Your **Color Picker** at the bottom of the **Toolbox** will have two squares most probably one black and one white, placed diagonally. The top left square shows the color that is currently available for use by the **Brush Tool**. If the top one is black and the bottom one is white, click on the double arrow between the boxes to reverse them.

Now anywhere you paint with the white color will allow the effect of the new **Layer** to show through. You can also use grey if you want only a partial effect to show through.

If you make a mistake, you can click again on the double arrow to paint black on the **Layer Mask**, again hiding the effect of the **Levels Layer**.

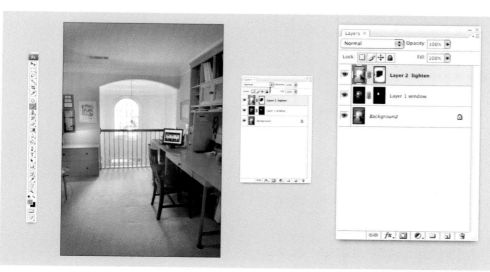

NOW WE ARE GOING TO GIVE THIS ROOM A **DRAMATIC LIGHTING MAKEOVER** USING THE SAME TECHNIQUE AS ABOVE.

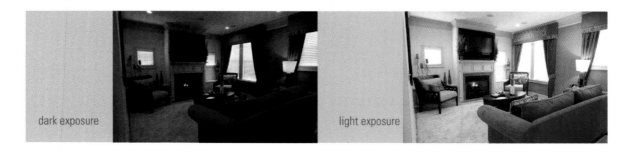

dark exposure

light exposure

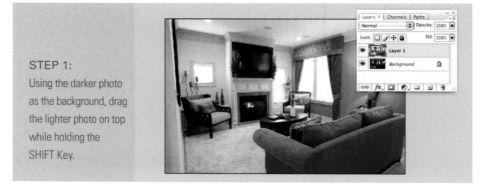

STEP 1:

Using the darker photo as the background, drag the lighter photo on top while holding the SHIFT Key.

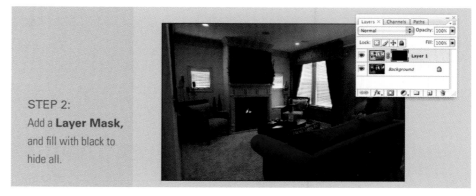

STEP 2:

Add a **Layer Mask,** and fill with black to hide all.

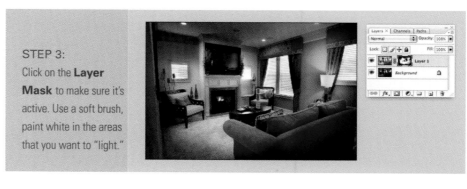

STEP 3:

Click on the **Layer Mask** to make sure it's active. Use a soft brush, paint white in the areas that you want to "light."

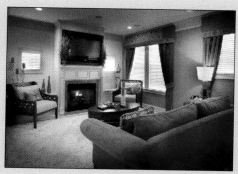

### STEP 4:

When you like what you've done, save it. Flatten the Layers, In this case, the verticals need to be straightened, so we'll SELECT ALL, then EDIT > TRANSFORM > SKEW. Click and drag the bottom corner handles until the verticals look straight. Click ENTER to apply the Transformation.

### STEP 5:

Use the **Cropping Tool** to finish, then do a SAVE AS with a different name. (This way, you have the un-flattened version as well in case you want to go back and work on it some more.)

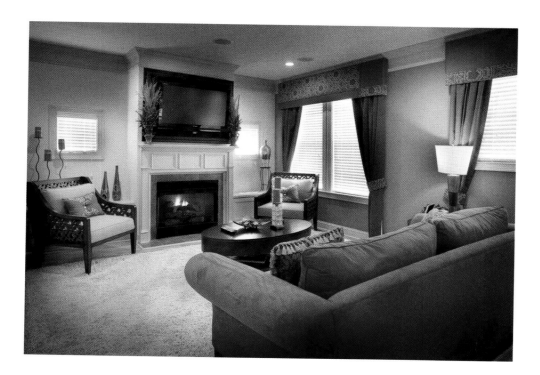

**METHOD 2**

Method 2 is similar to Method 1, the difference being that instead of using actual photos that are lighter and darker, levels (or curves) adjustment layers are used.

STEP 1: Open your photo in Photoshop or Photoshop Elements.

STEP 2: Go to LAYER > NEW ADJUSTMENT LAYER > LEVELS.
Move the middle slider to the right, causing the photo to look darker.

Use the **Layer Masks** as in Method 1 to determine what areas you'd like darker.

▰▰▰▰▰ Replacing Windows

We know how dramatic it can be to combine incandescent light with that deep blue color we get outdoors at dusk. Here is a way to get that effect even if we were not at the location at the best time to get it done in one shot.

We'll start off with a night interior photo and a dusk exterior photo.

The first step is to combine the two images into one file. Click on the outdoor photo to make it active. Click on the **Move Tool** (circled in the Toolbox), and click and drag the outdoor photo onto the interior photo.

The outdoor photo automatically becomes a new **Layer**, as shown in the **Layers Palette**.
At the top, go to LAYERS > ADD LAYER MASK > HIDE ALL. The outdoor **Layer** disappears,
hidden by the **Layer Mask**.

Now comes the tricky part. We need to make a selection of the windows.
Click on the bottom **Layer** to make it active.

There are several selection tools that you can use, but start with the **Magic Wand Tool**. Click anywhere within one of the windows, and you'll see the "marching ants" indicating your selection. You can add to the selection by holding the SHIFT key as you click and subtract from the selection by holding the OPTION (Mac) or ALT (PC) key while you click in an area that might have inadvertently gotten selected. You can vary how much gets selected by changing the **Tolerance Setting**. Make sure that you have "contiguous" checked or everything in the photo with that same color will be selected.

Working with the **Magic Wand** and the other selection tools takes some practice. A very cool way to continue is to switch to the **Quick Mask Mode** found at the bottom of the **Toolbox**.

The **Quick Mask Mode** allows working with a brush to paint in your selection using black or de-select by painting with white.

When you're satisfied with the selection, click back to the **Standard Mode** (with the marching ants). Go to SELECT > MODIFY > FEATHER, and enter 1 pixel to make it look a bit more realistic and less like a cut out.

Click on the top **Layer Mask** (the hidden outdoor photo) to activate it. Go to EDIT > FILL and select white. This will paint white onto the **Layer Mask**, just in the areas where the windows are, and let the hidden **Layer,** the outdoor photo, show through. (You will see the change on the **Layer Mask** as well.)

Reduce the opacity of the **Layer** (circled) to where some of the window reflections come through so that it looks like there is glass in the windows.

## Typical Problems, Photoshop Solutions

Keep in mind that in Photoshop there are many ways of solving any problem. Photoshop offers some automatic fixes which you are welcome to try, but I will not get into those as they offer less control.

I suggest that before you start working, make a copy of your original and work on that.

If you've read the previous information on Photoshop, some of the following may seem redundant. In fact, some may seem excessively redundant. But, next are summaries of some of what we talked about previously, along with some additional step-by-step quick fixes.

### VERTICALS SLIGHTLY OFF

Reduce size of on-screen image by using the **Zoom Tool,** or pressing COMMAND (Mac) or CONTROL (PC) and the MINUS SIGN. (CONTROL + PLUS SIGN will enlarge the view.) Once the image is small enough that you can see the whole image, with some space around it, SELECT > ALL. (You may need to move your mouse to the corners of the background until the

cursor changes to a two-headed arrow, then drag out the background to give you some room to work.) You will see the "marching ants" around the border.

Go to EDIT > TRANSFORM > SKEW. Click on the tiny squares on the corners and drag outwards until verticals are straight.

## COLOR TOO BLUE, YELLOW, RED, GREEN, OTHER

**Simple method (Elements):** Go to ENHANCE, then click any of the color correction options. ADJUST COLOR > COLOR VARIATIONS is a good place to start.

**Better method:** Go to LAYER > NEW ADJUSTMENT LAYER > HUE/SATURATION. Make your adjustments using the drop down menu for individual color adjustments, then save as a Photoshop file with both layers. When you are satisfied with the image, flatten **Layers**, resize as necessary, and save as either a TIFF or a JPEG depending on your usage. Keep the original Photoshop (PSD) file for future use.

**Alternative method (Elements):** Go to ENHANCE > ADJUST BRIGHTNESS/CONTRAST > LEVELS. Click the middle eyedropper. Drag the eyedropper over the image and find an area that is neutral grey. Click on this area and see if the overall color balance improves.

You can use this same method with a **Levels Adjustment Layer** instead of using the **Hue/Saturation Layer** method above. If the adjustment is too strong, go to WINDOW > LAYERS, click on the **Levels Adjustment Layer** that you just created, and reduce the opacity (top of window).

## EXPOSURE TOO DARK OR TOO LIGHT

**Simple method (Elements):** Go to ENHANCE > ADJUST BRIGHTNESS/CONTRAST > LEVELS. Move the slider on the left towards the center to make the dark areas darker, move the slider on the right towards the center to make the light areas lighter, move the middle slider to the left to lighten the middle tones, move the middle slider to the right to darken the midtones.

**Better Method:** Go to LAYER > NEW ADJUSTMENT LAYER > LEVELS. Move the slider on the left towards the center to make the dark areas darker, move the slider on the right towards the center to make the light areas lighter, move the middle slider to the left to lighten the middle tones, move the middle slider to the right to darken the midtones.

Save as a Photoshop file with both layers. When you are satisfied with the image, flatten layers, resize as necessary, and save as either a TIFF or a JPEG depending on your usage. Keep the original Photoshop (PSD) file for future use.

## AREAS IN PHOTO WAY TOO DARK OR TOO LIGHT (TOO MUCH CONTRAST)

Method 1 and Method 2 (above) are powerful techniques that allow you to create a photo that looks like you've spent hours lighting the set.

**In addition, here's method 3:** Use the **Shadow/Highlight** command. Play with the settings to learn the subtleties. This is a very powerful tool and easy to use.

## TOO FAR AWAY FROM SUBJECT

**Use the Cropping Tool.** (Watch your settings.) Keep in mind that if your final image size has not changed, your image will be at a lower resolution. Also, be careful about specifying size and resolution in the **Cropping Tool** settings, as you may unwittingly throw away information or add interpolation (information that the computer "guesses" should be in the image).

## UNWANTED OBJECTS IN PHOTO

Use the **Clone Stamp Tool**. ALT+CLICK on an area that you want to pick up detail from and release the mouse button. Scroll the mouse over the unwanted object, click and drag. Keep in mind that as you "paint," the area that you are selecting as your source is also moving.

## WHITE SKY

Use the **Magic Wand Tool** to select the sky. If there are lots of small areas of sky that aren't being selected, such as sky seen through tree branches, uncheck the box that says "contiguous" and try again. If only parts of the sky are being selected because of variations in tone, increase the number in the box that says "tolerance." If too much is selected in addition to the sky, decrease the tolerance.

If you are having trouble with the sky selection, you can use any of the other selection tools to add to or take away from what is selected. If you are using the **Lasso Tool** or any of its variations, holding the SHIFT key while you use the tool will add to your selection, while holding the OPTION (Mac) or ALT (PC) key will take away from it.

Once you have your sky selected, it is usually a good idea to save the selection by going to SE-LECT > SAVE SELECTION, then name it "sky selection" or whatever. That way, if you accidentally hit the wrong key, or later you decide to make some adjustments, you can go to SELECT > LOAD SELECTION, and, voilà, there it is again.

Another good thing to do is to feather the selection, which makes the line a little softer and more natural. Go to SELECT > FEATHER SELECTION, try setting it at 1 or 2 pixels. If it turns out later that the selection does not work well, for instance around tree leaves, etc., you can try modifying the selection by going to SELECT > MODIFY > EXPAND or any of the other options in the SELECT menu.

Still with me? OK, here's the fun part. Go to LAYER > DUPLICATE LAYER. Make sure that the new **Layer** is active (highlighted). Click the **Foreground Color box**. In the **Color Picker** that opens up, look for a good sky color. Don't over do it. It's best to be somewhat subtle. That means, instead of going for a pure blue, move over a bit to where the color is less intense or saturated. Click on the color you like, hit OK, and get back to the image.

Make sure that the **Set Background Color Box** is white. If not, click on it and select white as you selected the blue above.

Click on the **Gradient Tool.** It looks like a rectangle filled with a tone going from black to white. Bring your cursor to the top of the sky, click, and drag downwards, just past where the sky selection ends. You should see a line as you drag the cursor. Now release the mouse button, and admire your first attempt at creating sky. Too cool.

If it's not perfect, press Command+Z (Mac) or Control+Z (PC) and try again until you get a sky you like.

Since you had the forethought to create your sky on a new layer, you can also go into the **Layers Pallet**, select the **Layer** with the sky, and decrease the opacity with the slider at the top of the pallet. This can give you a more natural looking sky.

**Simple solution:** Similar to above, but no sky selection necessary.

Instead of creating a **Duplicate Layer**, create a **New Layer**. Once you've done your gradient, at the top of the layers pallet, go to the **Blending Mode** drop down menu and choose **multiply or darken**.

This will have a similar effect as if you had a filter in front of the camera lens. It will darken the sky as well as any objects under the blue gradient, such as trees, rooftops etc.

## RAINY OR OVERCAST DAY

Previously, we talked about the advantages of taking photos on a cloudy or overcast day, and then using Photoshop to enhance the image. In some cases, an overcast sky solves the problems of unwanted shadows or other lighting problems that you might encounter on a sunny day. And then there are the times when you just don't have a choice.

The problem with an overcast day is that it looks cold and gloomy. Fortunately, we can use Photoshop to replace some of the color that the cloudy sky filters out. A cloudy day tends to have less yellow and red, the colors are less saturated, and overall the lighting is less contrasty than on a sunny day.

Start by going to LAYERS > NEW ADJUSTMENT LAYER > HUE/SATURATION. From the pull down menu, choose Yellow, and move the slider to the right until you like the look. Do the same after selecting Red from the pull down menu. Click OK.

Go again to LAYERS > NEW ADJUSTMENT LAYER > LEVELS. Drag the two sliders inward to increase the contrast slightly. You should now see a major improvement.

If you want, you can do another **Hue/Saturation Layer**, and increase the saturation, although having increased the contrast with the **Levels Layer** may be sufficient.

Add sky as necessary.

As always, when you are satisfied with the image, flatten **Layers**, resize as necessary, and save as either a TIFF or a JPEG depending on your usage. Keep the original Photoshop (PSD) file for future use.

## RAW Files

### "RAW RAW RAW, THAT'S THE SPIRIT!" (FIRESIGN THEATER, CA. 1970)

I'm kind of a cheerleader for raw files. A raw file is basically the raw data that your camera captures before it modifies the file to make what it considers to be a pretty picture. Photoshop as well as several independent companies offer ways of taking this raw data and interpreting it to make a pretty picture the way you as the photographer wants.

Why bother, you may ask? Because aside from the extra degree of control, you can now make corrections that you couldn't do otherwise. Say, for instance, you had the camera set on daylight and realize afterwards that it should have been set for tungsten. Sure, Photoshop is great for correcting color, but with a raw file you can make the adjustment as if you had it set correctly in the first place.

As for exposure, again you have much more latitude with a raw file. In fact, you can take the same raw file and "develop" it several times, giving you several darker and lighter exposures which you can combine in Photoshop to preserve many more tones than you could get otherwise.

The best analogy, for those of you that remember shooting film, is that a raw file is like a negative, where you can adjust exposure and color when making a print, as opposed to a JPEG or

TIFF from the camera, which is like a slide or a transparency, with much less room for error. In one of the examples above, we used Photoshop's levels and color correction adjustments to make a cloudy day look brighter and warmer. You can do the same corrections when converting a raw file, with more latitude and better results. You will see options for color temperature, which can make the image warmer or cooler looking, and exposure, contrast, shadows, and brightness controls. Once you have these controls set the way you like them for a particular image, if you have other photos taken in similar conditions, you can save these settings and apply them to the other images with a single click.

Raw files are not changed when you bring them into Photoshop. The original raw file remains intact, so that you can go back at any time and make another conversion from the same file.

## THE ETHICS OF PHOTOSHOP

When photography started going seriously digital, the publishing world went into turmoil. There was much hand wringing and gnashing of teeth about whether photographs could ever again be trusted. The major magazines huddled together and came up with labels and disclaimers that would be attached to images that were computer manipulated.

The truth of the matter is that traditional photographers had been doing much of what Photoshop can do back when laptop computing was done on a slide rule. In fact, many of the tools in Photoshop are based on traditional darkroom tools and techniques. Photoshop does, of course, make it easier to do image manipulation, and does it so well that it is almost impossible to detect, so use, but don't misuse. It's just common sense.

## JUST FOR FUN: MAKING PEOPLE DISAPPEAR

What do you do if you're trying to photograph a building, say, in a downtown setting, and there are people in the way, walking and driving around, apparently oblivious to your growing angst? Assuming that you're not Steven Spielberg and can afford to close down the street for a few hours, here's a great method.

Set up your photo as usual with your camera on a good steady tripod, of course, and with your trusty cable release (also, of course). Get your composition as you like it, and adjust your camera for proper exposure. You might want to take a photo now for comparison.

Next step is to adjust your f-stop and shutter speed combination to give you the slowest shutter speed possible while still maintaining proper exposure. You will be limited by your f-stop. You can set your camera on aperture priority and choose the smallest opening. That way, even if the lighting changes as you are working, you will always be using the slowest shutter speed possible. If your shutter speed is now several seconds, that's what we're going for.

What if it's too bright outside to get a multi-second exposure to work? The traditional standard camera for serious architectural photography was for many years, and in many cases still is, the view camera. The view camera typically had a lens that was able to be stopped down to f/64 or even f/90. The digital camera that you're using probably stops down to about f/22 or f/32, which is two to five stops more open than the view camera. You have a few options. On a digital camera, reduce the ISO to the lowest setting. On a film camera, use a slower speed film. You can also use neutral density filters, a polarizing filter, or shoot on a less than bright sunny day.

This is what we're trying to accomplish. If your shutter is open for several seconds, anything that is moving will blur. If the shutter is open long enough, and if the object or person is moving quickly enough, not only will it blur but it won't have time to actually register in any one place on the film or chip. In effect, it will disappear!

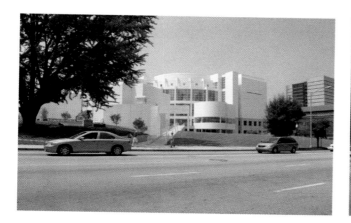

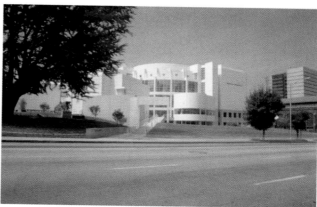

Because I love a challenge and thrive on frustration, I shot the above photos of the High Museum in Atlanta: a white building, at high noon, in the hot, sunny South, at lunch hour.

To cut down on the light, I used a polarizing filter in combination with two neutral density filters. The filters were each rated at a three stop density. I set my camera to its smallest aperture, f/22, and let the shutter speed fall where it may. Because I was using the smallest aperture, which let in the least amount of light, my camera automatically set on the slowest shutter speed that would give correct exposure.

This series was done at shutter speeds from 1/150 second (top) to 5 seconds (bottom). At 5 seconds, the people and cars in the bottom photo virtually disappear, although on close inspection you could see some blurs. Depending on the speed of the traffic and the pedestrians, I would suggest aiming for ten seconds to be sure. If you can, do the photos on a less sunny day.

This method works great in many situations. If, however, there are crowds of people, one essentially replacing the other in position within the frame, the results will not be as good. Experiment with different f-stop shutter speed combinations and see what you get.

In some circumstances with lighter traffic, you can try the high tech method for dealing with the same situation: make several identical exposures, then bring them into Photoshop, layering them as one document. Use the unobstructed areas from different layers to combine into one clean photo.

**ANOTHER GREAT TECHNIQUE:**
PAINTING WITH LIGHT AT NIGHT

Painting with light is another old technique which, in all likelihood, you'll never need to use but it can be dramatic. Set your camera on the tripod and, while keeping the camera shutter open, walk around pointing a floodlight or other light source at your subject. The shutter is kept open for the minimum amount of time necessary to avoid other light in the environment from affecting the photo, but it could be open anywhere from a few seconds to many minutes. The photographer usually wears dark clothing to avoid any chance of making an unexpected cameo appearance in the photo. This technique is used when the subject is very large and it would be impractical to set up enough lights to effectively light the subject. I've seen this used for photographing locomotive at night. It is also great for lighting small areas, as was done with the canoe on the cover photo. A variation of this technique has been used where many people, armed with small flashes (like you would use on top of your camera), synchronized their flashes to light a large aircraft carrier. Very, very cool.

## Panoramas

A panorama is essentially a photo that is extended usually horizontally, using a process known as "stitching" several photos together. You could, of course, just take any photo and give it an extreme horizontal crop, but you'll want to do a panorama when:

1. you need to maintain good detail that would otherwise be lost by taking a small image and enlarging it, and/or

2. you want to show a wider view than your lens will allow.

You can create a panorama by rotating the camera on the tripod, or if you want to avoid the fisheye look, you can keep the camera angle consistent and move the camera and tripod laterally, parallel to the subject. Either way, if you are far away from the subject, you will have less of the fisheye look (which has its purposes, just not here).

Photoshop has a tool called **Photomerge** that automatically combines several photos together to create a panorama. In the newer versions of Photoshop, this tool has really been improved to where it can do miracles. How successful Photoshop is at doing this for you is dependent mostly on how you take the photos that are to be merged.

To use **Photomerge**, in Photoshop go to FILE > AUTOMATE > PHOTOMERGE.

### HERE ARE A FEW TIPS:

*Use a tripod. (Have I mentioned that before?) Plan out your panorama by setting up the camera on the tripod and rotating it to ensure that the photos will be level. (A rotating head on the tripod is very helpful.) On the other hand, if a great opportunity presents itself, go for it, and don't worry so much if you don't have a tripod.*

*Set your camera exposure mode to manual so that you won't have dissimilar lighting. Check the exposure for the different views, and try exposing all with the settings that you would use at the brightest point. This will prevent having burned out areas with no image information.*

*Set the camera for a fixed white balance, not automatic.*

*Overlap each photo about thirty percent.*

*Photoshop may have trouble with photos taken with an extremely wide-angle lens.*

*Don't change the zoom or focus between photos.*

*Don't use a polarizing filter.*

When you take a photo with a wide-angle lens, the sides of the image are "distorted" compared to the center. If you just took two images and tried to put them together, you'd find that the objects on the edges would not align properly. The computer takes into consideration these factors and stretches and compresses the images so that they align.

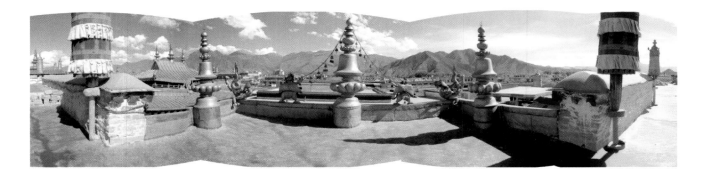

The curved borders in the above panorama show how the computer manipulated the images so that they would fit together. In most cases, you'll want to keep your photos "loose." In other words, leave enough image area around your subject so that you can crop into the final image. In this case, I found it more interesting considering the subject matter to let the borders go "natural."

The software is able to compensate somewhat for differences in exposure. But again, get as close as you can for the best results.

You will probably have better luck with objects that are not real close to the camera, and might have problems if you are photographing a small room. Experiment beforehand if you can.

## ADVANCED PANORAMA TECHNIQUE:

For perfect results, especially when photographing scenes with far and near objects, you will want to learn where the "nodal point" is on the lens that you are using. Ideally, the camera should rotate around this nodal point to prevent "parallax." Parallax is when a scene is viewed from different positions, which causes elements to overlap differently in each different view. You can observe the effect of parallax by sitting at your desk and closing each eye independently. Notice the shifting of the objects on the desk. (The effect is what enables us to see in three dimensions.)

### What Is A Nodal Point, and How Do I Find It?

A nodal point is the point within a lens where the light rays cross before hitting the film or the sensor. For perfectly aligned panoramas, your camera should rotate exactly around this point.

To find the nodal point you will need either an adjustable bracket as mentioned above or a tripod with a head that allows "fore and aft" adjustment, and also has the mounting screw centered left and right with respect to the lens. Of course, this assumes that the tripod mount hole in the base of the camera is also centered.

Set up a scene where you have an object in the foreground, such as a sign pole, aligned visually with an object in the background, such as the corner of a building or the edge of a doorway. With the camera on the tripod and the lens focused on infinity, rotate the camera and observe the shifting of the alignment of the two objects. Unless you're incredibly lucky, there will be a visual shift.

Assuming that the camera lens is centered left to right, move the camera slightly forwards and backwards (towards the subject and back towards you), and observe the shifting. Keep doing this until there is no apparent shift. Congratulations, you've found the nodal point.

Mark this point on your bracket or tripod for future use.

HERE IS AN INTERIOR PHOTO DONE AS A PANORAMA.

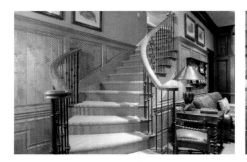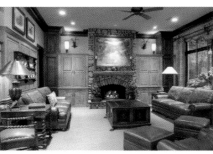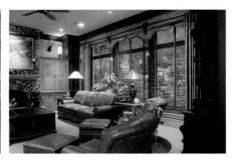

Because this photo is comprised of three separate high resolution photos, the total resolution on the finished product is very high; great for making a very large, impressive, detailed print.

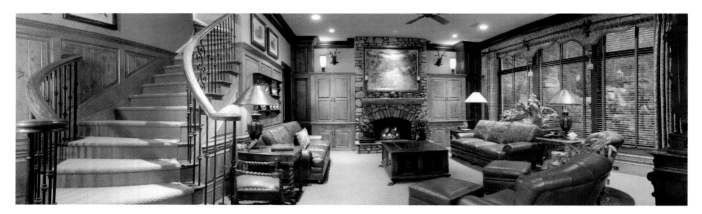

## Virtual Reality

Virtual Reality (VR), sometimes called Virtual Tour in the real estate world, is kind of like an electronic panorama on steroids. You can produce a panorama that goes in a 360 degree circle, as if you are standing in the middle of the room. Using the mouse, the viewer can control the angle of view, and the image can be set up to move horizontally and vertically.

Virtual Reality is used most often to show interior spaces. It is produced by putting the camera on a bracket that is mounted to the tripod. The bracket helps to align the camera and has click stops to indicate how far to rotate the camera between images. The images are then stitched together in a software program that produces the viewable VR.

Panorama Factory is one of the available programs that can help you to produce VR.

# Color Management, File Formats & Specialized Formats

## Color management

Color management is the art and science of making sure that the color you see through your camera is the color that shows up on your computer monitor, which is the color that prints out on your desktop printer, or on your four color brochures, or on the Internet. Sounds simple? It's not. It can make your head spin. If your prints and brochures are coming out pretty close to what you expect, don't worry about it. For most of what you'll be doing, unless it's high end magazine work, you should be fine. Just know that there are computer programs and hardware that deal with this issue, and people that specialize in this. If you are working with a printing company, ask them for their specs and some hand holding.

Note: If you are having major problems getting color right on your inkjet printer, make sure that the heads are clean. A clogged nozzle can give your prints a color cast. On an Epson printer, go to **utilities,** then **nozzle check**. If the printed pattern shows gaps, clean the nozzles once or several times until the pattern prints out correctly.

## Common file formats

There are several ways that a photo can be stored in digital format. Three of them, JPEG, GIF, and PNG can be used for images displayed on the Internet. Each has advantages and disadvantages and is most appropriate for certain types of images.

### JPEG

JPEG stands for Joint Photographic Experts Group. It is the standard means for taking a photographic image and reducing the file size. It is the method of choice for photos on the web.

JPEG is a "lossy" process, which means that it throws away data that is considered not necessary. It is a good idea to avoid saving and resaving JPEG files, as image quality will be reduced.

When you save a file as a JPEG, you are given a choice of quality versus file size. Your decision should be based on the final usage of the image. If you are saving it for the web, you'll want to keep quality as high as possible while keeping the file size down to enable quick loading of the image on a web page. If you are saving the file to go to print, it would be best to go for better quality. However, for high quality printing, it is better to save images as uncompressed TIFFs.

In Photoshop, there is an option to "Save For Web." Use this if you are saving for Internet use, as opposed to going to FILE > SAVE AS, then choosing JPEG.

### GIF

GIF stands for Graphics Interchange Format. GIF format is a lossless compression method, and GIF files are better suited for illustrations that have flat colors, such as cartoons and logos, and for lettering and graphics that have lines and edges.

GIF files also have the advantage of supporting transparency. This means that you can select a color in your image that will appear transparent on the Internet. This is very useful if for instance you want an image to appear to float on the web site background rather than have its own background.

GIF files can also be used for small animations.

GIF was developed by Unisys for CompuServe back in 1987. Patent issues may make it less desirable for some developers to use as they are legally required to obtain permission and possibly pay royalties to use this compression method. Don't panic though, the usage issues and royalties don't apply to us little guys.

JPEGs are generally better than GIFs for photographs, as they will give smoother gradations.

### PNG

PNG stands for Portable Network Graphics. It is relatively new (developed in 1995) and is not supported by older web browsers. PNG was developed in response to the patent problem of GIF and allows more compression than a GIF file, as well as control over the degree of transparency. It does not, however, support animation as GIF does.

PNG is superior in many ways to GIF and may eventually replace it.

## Other formats

### TIFF

A TIFF file gives you a full uncompressed image file. This format is best for storing and transporting photos, as long as you have the storage capacity.

### PSD

PSD files are Photoshop files. Most importantly, you can save a file with all layers as well as other Photoshop information intact in a PSD file format. PSD files are normally used for storing images to be worked on again or when images in progress are shared with other Photoshop users.

### RAW VS. JPEG

Many cameras offer the choice of raw or JPEG for saving images. As previously discussed, raw will allow the most flexibility and allow for best image quality. The advantage of JPEG is that you can fit many more images on your Compact Flash card or other camera recordable media.

If you select JPEG, you will be given a choice of quality in the camera settings with the purpose being to allow more files to be stored versus quality.

# Hiring a Pro

5

## Hiring a **Pro**

### How to Work with a Professional Photographer

You've got that special project, up against a deadline, or maybe you're looking for a way to spend Great-Grandma's inheritance, so you've decided to hire a professional photographer. Unless you've skipped to this chapter, you should by now have a pretty good idea of what's involved in doing a photo project, as well as a pretty good understanding of the terms, tools, and techniques that a photographer will utilize. So, consider yourself way ahead of the game.

### When and Why Should I Hire a Professional?

Generally speaking, you should hire a professional photographer whenever you can. People can sell houses on their own, and many times it works out great for them. But utilizing the experience of a professional realtor can save time, money, and avoid problems. The same is true for hiring a photographer.

### How Do I Find A Good Professional?

As with anything, word of mouth is a great resource. Your colleagues might have hired someone that they're happy with. Yellow Pages, Internet search, etc., all work.

Another great way to find a good photographer is through the web sites of professional photography organizations, such as APA (Advertising Photographers of America), and ASMP (American Society of Media Photographers). For links to these and other sites, please go to www.photosthatmovehouses.com.

### What Will I Be Buying?

Let's start with what you will not be buying…a piece of paper with ink. Unlike walking into a gallery and buying artwork, when you deal with a commercial or architectural photographer,

you are buying rights to use his or her images. The cost of buying these rights is usually dependent on the final usage. For instance, if you want a photo of your store to hang on your living room wall, it probably will cost you less than if you want to use that photo in a national ad campaign in major magazines or plastered on outdoor boards along I-95.

Commercial photographers may base their fees on a day rate or a creative fee. Added to this are charges for all expenses such as assistants, travel, props, models, crew (such as make-up artists and stylists), retouching, film, processing, and Polaroids or the modern day counterpart, a digital capture fee. The digital capture fee covers the process of getting the photos from the camera into the computer, possibly some basic Photoshop adjustments, and burning the files onto a CD or other media.

The resulting price is then modified by the usage rights, which includes period of use. A standard starting point is usually for a year's usage time. If you want to own the images as well as the copyright, this is called a "buyout." It can be somewhat expensive, although everything is usually negotiable.

I usually offer the client a job price rather than an open-ended day rate for most assignments, as it tends to avoid nasty surprises for the client. Of course, some jobs have many variables such as weather and accessibility, but I try to get as close as I can and let the client know what the variables are and how they might affect the price.

A photographer technically owns the copyright to an image as soon as the shutter is clicked. Many people feel uncomfortable about hiring a photographer and not owning the images. Although in many cases you can negotiate for ownership of the photos, you might consider the fact that by buying only the usage rights that you need, you can save a lot of money.

Whether the photographer can sell the images for other purposes is also negotiable. In most cases, a photographer will not sell images during the period of usage that the client has paid for, but might want to use the images for self promotion. After that period of time, depending, of course, on the appropriateness of the images, a photographer might want to include the photos in his or her stock collection to be offered for use by other clients.

You can find more information on this subject on the web sites for the American Society of Media Photographers (ASMP) and the site for the Advertising Photographers of America (APA). (Links available at www.photosthatmovehouses.com)

There are also photographers that specialize in working with real estate agents. They may offer a simplified "package deal" type service.

Be sure to look at samples of any photographer's work before you make a decision.

## ▬▬▬ Talking the Talk

I have had people call me and say, "What do you charge to take a picture?" Assuming that you are not going for the above mentioned package deal, and depending on the complexity of your project here are some of the things a commercial or architectural photographer will want to know:

SUBJECT. What/who will be photographed?

PEOPLE/TALENT. If you are including people in your photos, will a make up artist, wardrobe, and/or hair stylist be required? Who will arrange for talent, hiring models, make-up artist(s), stagers and stylist(s)? How about food? (A well fed crew is a happy, productive crew!)

NUMBER OF PHOTOS REQUIRED.

LOCATION(S). Will there be any major travel involved? Who will be coordinating travel arrangements?

USAGE. Will the photos be used in brochures, magazines, print ads, Internet, etc.

USAGE PERIOD RIGHTS. How long will the photos run? What rights do you require?

DEADLINES. What is your production schedule? If you are planning to use the photo in a print ad, make sure you know the closing dates and material dates for the publication. Work backwards in developing your production timeline.

FORMAT. Most photography work is now done digitally. Do you have any specific requirements such as larger files that might require special equipment? If, for some reason, you do not want the photos done digitally, what film will be required? Will it be negative film (for photographic prints) or transparency film (best for printing press work)? What size: 35mm, medium format 2¼ x 2¼ , or 4 x 5 view camera?

OTHER SERVICES. Do you want the photographer to supply the retouching (Photoshop), conversion to CMYK, printing of the final output as in the case of brochures or catalogues, other crew such as prop stylists, or location scouts?

If you can provide samples to the photographer of other work that you've had done or even pages from a magazine or brochures from other companies, these visuals can be extremely helpful in communicating your goals to the photographer. Let the photographer know what you like about the samples and what you would like to see done differently. Having these samples in digital form so that they can be e-mailed can expedite the process, especially if you are communicating with more than one photographer.

**Sounds complicated?** Hey, it's not easy for us of the teeming masses to buy a house or choose drapery colors either. But it's really not that bad. And one more important point: when deciding on a photographer, make sure that you like him or her. You're going to have a lot of communication back and forth, and despite all of the above, it should be a pleasant experience, so make sure the chemistry is right.

And if you learn any great tips and techniques, let me know.

For more information, please visit:
www.photosthatmovehouses.com